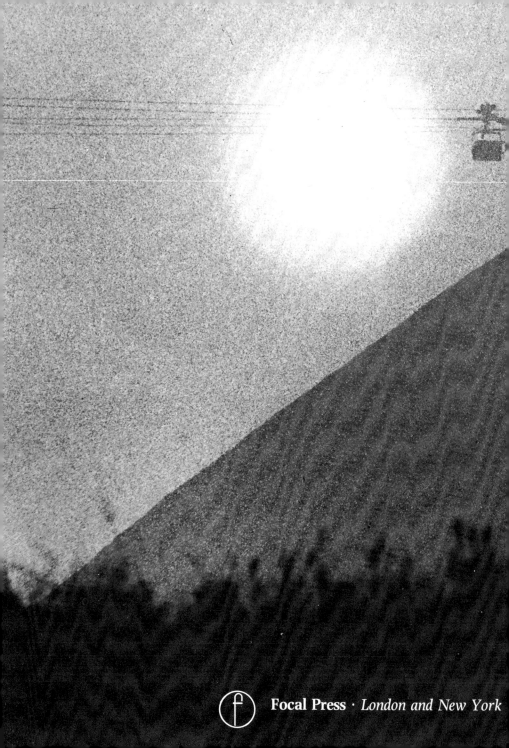

Focal Press · *London and New York*

Photography Materials and Methods

John Hedgecoe and Michael Langford

London · Oxford University Press · New York · Toronto

Acknowledgements

The photographs which appear in this
book were taken for:
Queen Magazine, Plates 2, 4, 6–7, 11, 13,
17, 19, 22, 24, 27, 30, 43–4, 46–8, 53–4,
C2–3, C5–6, C9–10, C13, C16, C18;
Henry Moore by J. Hedgecoe (Nelson),
1, 3, 31, 32, 33 & 36; Gulf Oil Company
Limited (Young & Rubicam), 28; British
Iron & Steel Federation, 10–12;
The Observer, 15 & 53; *M* Magazine,
C4 & C15; *Nova* Magazine, 18; *Sunday
Times*, 35, 37, 40 & 47; *Go* Magazine,
49 & 50; *Tatler*, 5; *Woman's Mirror*, 29;
House and Garden, 32; Pye Limited
(Cassons), 14; Gilbey Limited
(Ogilvy & Mather), C7; British
Holiday & Travel Association
(Ogilvy & Mather), C1; Brooke Bond Tea
Co. Ltd., C8; Design Research Unit, C14.

ISBN 0 240 50895 5

This edition 1974

Text set by Keyspools Ltd and printed in Great Britain
at the University Press, Oxford, by Vivian Ridler, Printer to the University.
Colour origination by Colourcraftsmen Ltd, printed by Tindal Ltd.

Plate 1 *(on title page)*
Taken with a 1000 mm. lens on a
35 mm. camera using Tri X film.
Using such a long lens enables one to
get the coal heap and the sun in an
exaggerated relationship. Note the
shallow depth of field.

Contents

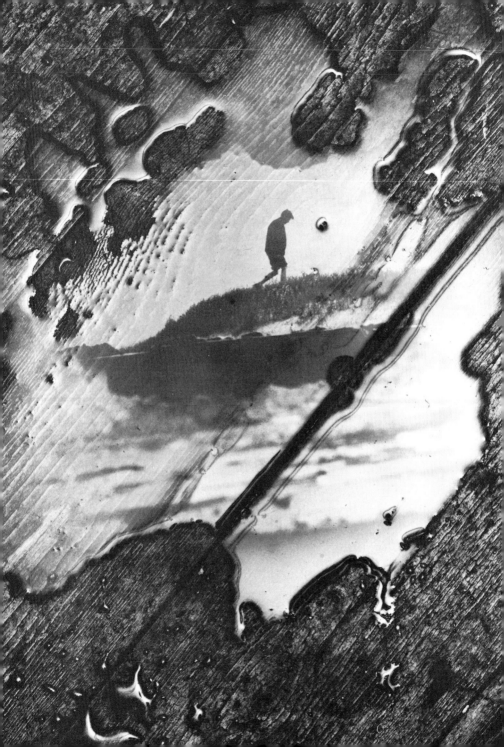

Introduction

Whether we like it or not, this is the age of photographic illustration. Artists and designers unable to use photography not only handicap their work but unnecessarily limit their visual experience. The once complicated techniques of photography have today lost most of their mystique—much has been taken over by film and camera manufacturers, and the remainder reduced to a straightforward routine.

This handbook is based on an introductory course we have run for art students, some of whom have never handled a camera or film before in their lives. Its aim is to encourage self-confidence in using a camera, by explaining how photography works in practical terms, and demonstrating the sort of images that can be produced.

The user of any medium has first to familiarize himself with its equipment and materials—therefore this book begins by describing the way a lens works and discusses practical features of seeing with a camera, exposing, processing, and printing black & white photographs. Other chapters introduce colour photography and discuss professional practice. We have tried throughout to keep technical terms to a minimum, explaining each as it is introduced. Wherever possible photographs themselves illustrate the points we are trying to make.

The photographic image has characteristics which make it differ from other media in several important respects. First, it is not necessary to have drawing ability to take photographs. As a drawing machine the camera offers accurate and superbly detailed information—in fact the camera usually draws too much, for it cannot itself differentiate between the important and the unimportant. A photographic image also differs from the eye in that its sharpness can be made zonal or overall. It can also record a split second in time, allowing a retrospective analysis of detail impossible at the time of shooting. Subject colour values are coded into tones on black & white films—tones which can be expanded or contracted at will. Similarly, although the camera may adopt only one viewpoint at a time, image perspective can be manipulated by camera position and choice of lens.

Finally the photograph still has an inherent, psychological truthfulness for the average viewer—probably because a real subject is normally needed. Modern man identifies with the photographic

ate 2
photograph produced
m two negatives, both
nned with the final
age in mind. Negative
a boy on sand dunes
ainst a white sky, was
er exposed to 'burn
t' sky and foreground
ail. Negative B, a
ddle on floor boards,
d white paper at the
r reflected into the
jority of the water
face. The two
gatives were then
nted in turn onto the
ne sheet of paper (see
ge 97). The final
ture was used
torially to illustrate
ne lines of poetry.

1

image, including film and TV. These aspects will be developed further in the technical chapters which follow.

PHOTOGRAPHY'S
HISTORICAL
PERSPECTIVE Photography is a nineteenth-century invention. From antiquity man had cherished the idea of fixing the reflections of the mirror and forming pictures without having to draw. Throughout the Middle Ages there are references to the use of the 'camera obscura' (darkened room). Basically this means the use of an aperture in the wall or shutters of a darkened room to project images of outside scenes onto the opposite wall, e.g. imaging the sun during partial eclipses Knowledge of the camera obscura certainly extends back to Aristotle from the sixteenth-century onwards a simple telescope lens was used over the aperture to give a clearer and brighter image.

However, despite the use of portable camera obscuras by landscape artists such as Canaletto to trace images by hand, no chemical means of recording seemed possible. It was not until the eighteenth century that the photosensitive (light-sensitive) properties of salts of silver were discovered by a German professor of anatomy, Johann Schulze.

It was a Frenchman—Nicephore Niepce—who in 1826 succeeded in making the first permanent chemical record of an image in the camera obscura. Niepce was interested in the new art of lithography and tried to make a light-sensitive litho plate using a mixture of white bitumen and lavender oil coated on pewter. Exposing this in the camera obscura for eight hours and then washing away areas of bitumen unhardened by light he recorded a positive image of a view from his house. Unfortunately his original aim of forming a satisfactory printing plate was never realized.

The first *practical* process for 'catching the image in the camera obscura' was developed by a fellow countryman, the painter Louis Daguerre. His *Daguerreotype process* called for the coating of a copper plate with silver iodide. This light-sensitive material was then exposed for a time in the camera obscura, but not enough to give a visible image. It was next 'developed' over heated mercury, giving a whitish coating only to the light affected areas and so forming a visible image. When the unused silver was removed from other areas with hyposulphate of soda a positive, permanent image was 'fixed' on the plate. Each Daguerreotype was an original, miniature 'drawing by light', full of fine detail and with accurate perspective (although laterally reversed). Daguerre's announcement of his process at a joint meeting of the Académies des Sciences and Beaux-Arts in 1839 created a furore among artists. At a time when the work of many eminent painters was judged by its accuracy and detail one

can sympathize with Paul Delaroche's agonized cry from the heart 'From today painting is dead'.

But in many ways the remarkable Daguerreotype was still very primitive. In its first few years (before lenses were improved) exposure of 30 minutes in sunlight was needed—consequently early Daguerreotypes were limited to still lifes and landscapes. Prints could not be made from these metal plates and although an Englishman, William Fox Talbot, patented his own process using silver salts on paper to form a 'negative' image (then printed onto further paper) the quality of his results was still not encouraging.

Talbot's negative/positive process (named 'Calotype') is important because it pointed the whole future technical direction of photography. Silver iodide soaked writing paper was exposed in the camera and then developed to form black silver in light struck areas. Remaining silver iodide was then removed in a solution of hyposulphite of soda and the paper negative washed and dried. Negatives were contact printed onto similar material by sunlight, and the processing cycle repeated to give positive prints.

By 1842 professional photographers (mostly Daguerreotypists) began to establish themselves in Britain. Amateur photography was virtually non-existent because anyone practising either process had to pay a substantial licence fee to Daguerre or to Talbot. The most lucrative and widespread market for pioneer photographers was portraiture for the middle class—a sector of society unable to afford their portraits in oils, yet overtly conscious of this status symbol of the aristocracy. Technical improvements had reduced exposure times, and with the aid of neck clamps and arm rests enthusiastic patrons sat out their petrified poses for a minute or so—at a guinea a time. Everyone admired the accuracy of the medium; miniature painting rapidly declined.

The photographers themselves were a mixed bunch of painters, dabblers in science, and astute businessmen. The first British Daguerreotype studio was opened in Regent Street, London by Richard Beard—an ex-coalmerchant. In Scotland (where the Calotype remained unpatented) landscape painter David Octavius Hill working with Robert Adamson produced some 1,500 fine calotype portraits and scenes of everyday life between 1843 and 1848.

Early Calotypes looked like purple-brown mezzotints, with a slight softening of detail owing to the structure of the paper negatives; largely because of this lack of detail they were not generally as popular as Daguerreotypes. In order to promote his process Fox Talbot published *The Pencil of Nature,* the world's first photographically illustrated book (1844). Each complete book contained

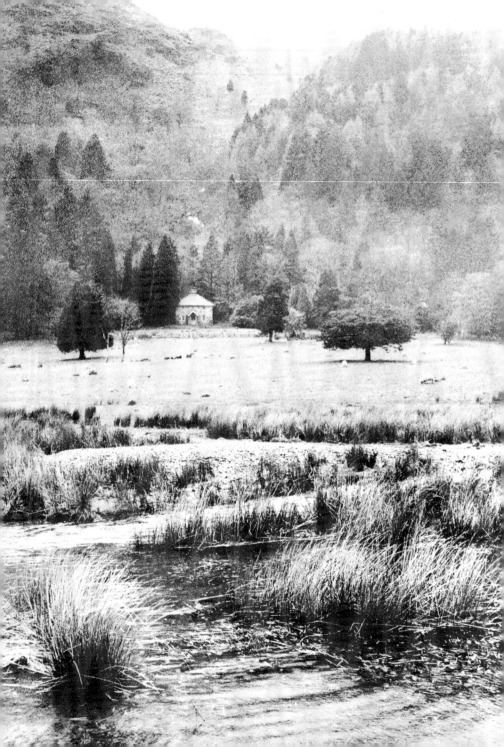

24 actual Calotype prints covering a range of subjects from still life to portraits. Nevertheless Daguerreotypes remained the preferred process in Britain, Europe, and America.

In 1851 a new photographic process using collodion to make silver salts adhere to *glass* plates swept Britain. The collodion process was originated by London sculptor Frederick Scott Archer; it was much more sensitive to light than calotype materials and gave negatives of exceptional quality. Equally important the process remained un-patented and thus for the first time photography was open to all.

The new process was even less easy than its predecessors—plates had to be coated by the photographer, then hurriedly exposed to the image and processed whilst still wet. The 'wet plate process', as it was soon named, was fairly practical in the studio, but location photography called for a darkroom tent, bottles, dishes, and barrels of water for washing the negative after processing. (Pictures tended to be taken near rivers or lakes—in fact any handy source of water.) But despite these practical difficulties the years following 1851 brought a great surge of Victorian enthusiasm for photography. Photographic societies sprang up all over the country, and were soon hotly debating whether this new form of communication was an Art.

People began to collect photographs avidly now that low cost multiple copies could be made from collodion negatives with the detail and quality of Daguerreotypes. Photography opened new windows on the world—pictures of notable people, travel records from distant lands and even scenes of domestic upper class life were sold in shops everywhere. Engravings and other drawn records dwindled in popularity. Stereoscopic prints and lantern slides (taken with a pair of cameras and viewed through spectacles) became enormously popular. Every Victorian parlour had a stereo-scope.

Intrepid photographers struggled up mountains, fought their way through South American forests, photographed from balloons, recorded the Crimean War and the American Civil War. The reality of photographic illustration was even able to influence political opinion.

At the same time unbounded contempt was expressed in artistic circles for the mechanical recording of contemporary life, which was itself held in disdain. Photographic realism both in art and literature was considered vulgar—the artificial was extolled. This led many photographers to attempt to imitate Academy painting of the period by means of contrived allegorical, historical, literary, and anecdotal photographs. Over-conscious of the mechanical aspects of the new

medium, photographers such as Rejlander went to endless technical pains to raise it to a High Art. Their pictures were built up from as many as thirty negatives—each carrying one element of the picture and printed in turn onto the photographic paper. 'High Art' photography was encouraged and admired by the critics of the day.

Most photographic portraits fall into the same trap—pretentious, stilted poses against painted backdrops. Few photographers attempted bold intimate impressions of their sitters as individual personalities. Julia Margaret Cameron's portraits of Victorian intelligentsia and the work of Paul Nadar are outstanding exceptions.

By 1878 the use of gelatine had superseded collodion as a binder of silver salts to glass. Gelatine plates could be given much shorter exposure times than collodion plates, and did not have to be exposed wet. For the first time 'dry plates' were manufactured for the photographer, and sold ready for use. These 'new aids to the pursuit of beauty' (as they were advertised) further expanded the possibilities of photography.

At exhibitions 'High Art' compositions were now countered by the naturalistic approach of photographers such as P. H. Emerson and later Alfred Stieglitz (influential leader of the 'Photo-Secessionists' group which introduced New Yorkers to *avant-garde* painters, sculptors, and photographers at the turn of the century).

In America too, Eadweard Muybridge, using rows of cameras triggered by tripwires, recorded for the first time the movement of animals and humans too fast for the eye to perceive. Muybridge's analysis of the leg positions of a galloping horse fundamentally influenced the painting of this subject. Painters experimented with angles and distortions produced by the new snapshot exposure times and hand-held cameras.

Photography still necessitated having one's own darkroom, knowledge of processing techniques etc. George Eastman's Kodak Company broke this technical barrier in 1888 with the first roll-film camera backed by a developing and printing service. All the user had to do was point the camera and press the button. Thus photography began to grow as a folk art. Huge financial returns to the photographic manufacturers from this mass popularization of photography supported research which subsequently led to the modern colour films we use today.

Photography's development in the last fifty years has been essentially towards visual maturity and diversity of applications. Instead of artifice and self-conscious imitations of paintings, photography is used to reveal diversity of form, shape, and colour in our

everyday world—to give expansion or compression of events in time and scale. Like books and sound recordings photographs give an opportunity for sustaining an experience—they are more throw-away and less acquisitive art forms than paintings. Far from competing with photography pop artists such as Rauschenberg and Warhol use photographs *per se* in collage.

The names which have influenced today's photographers are not those of the fine art photographers, but men such as Edward Weston, Bill Brandt, Irving Penn, and the doyen of photo-reportage Henri Cartier-Bresson. These and others have pioneered new ways of seeing with a camera.

The development of mechanical means of reproducing black & white and colour photographs on the printed page has emancipated photography just as the printing press freed the written word. The photographer now has a potential audience of hundreds of millions, and because of his medium (and its offspring film and television) a public more visually sophisticated than at any time in the history of communications. Simultaneously modern technology has made it easier than ever before to achieve results.

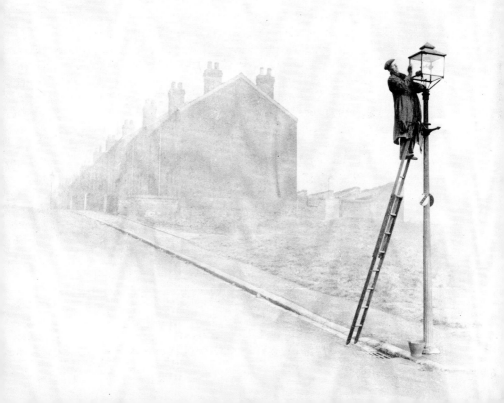

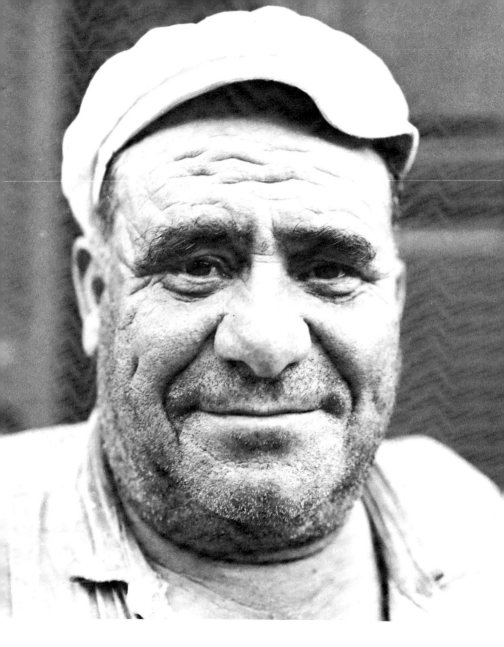

Plate 5
Portrait of a French
peasant taken with a
twin lens reflex camera
with close up lenses. The
limited depth of field
helps to emphasize the
squareness of his face.
One problem with close
up lenses (as opposed to a
long focus lens) is that
the camera ends up about
two inches from the
model's nose.
Consequently one tends
to get self-conscious
expressions.

CHAPTER 1 # Light and Lenses

Learning to use a camera is rather like learning to drive a car—at first the machine itself seems overwhelming, demanding fierce concentration, but eventually the mechanics diminish to a barely conscious routine. Whilst the mechanics of photography can never be completely discarded, it is possible with practice to make them sufficiently automatic for the camera to become an extension to the eye. We are able to concentrate on the end rather than the means. However, none of this freedom comes without training and practice, and first the novice has to consciously learn the controls.

LIGHT The word 'photography' is derived from two Greek words meaning to 'draw by light'. Light obviously plays the major role, so it is first necessary to look at some of its characteristics, as these lead logically to image forming and subject lighting.

Light itself is a form of energy radiated from a source (the sun, lamp filaments, etc.) It travels in straight lines, in wave-like motions at 186,000 miles per second. 'White' light is a mixture of wavelengths; narrower bands of wavelengths give rise to sensations of rainbow colours—blue, green, yellow and red—the familiar visual spectrum.

When light reaches the surface of our subject it may be reflected, transmitted, refracted, or absorbed. Light may be directly reflected as if from a mirror, or diffusely scattered as from white paper. It is directly transmitted through clear glass, and diffusely transmitted through translucent materials such as opal glass. Light may also be bent in its direction (refracted) if it reaches the surface of a transparent material obliquely. Hence it is bent when passing obliquely between air and water or from air to glass. Finally light may be absorbed by a dark material, usually being turned into heat.

Normally reflection, transmission, refraction, and absorption all

he wave-like concept
ght energy.
elength is measured
e distance between
consecutive crests;
n light, for example,
a wavelength of one
thousandth of a
meter.

9

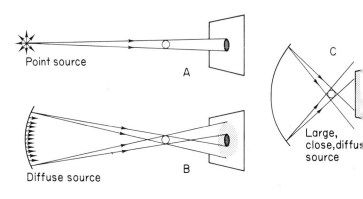

3. Shadow casting. *A* a direct, compact light source; *B* a diffused source; and *C* a large, diffused source close to the subject.

Point source

A

C

Large, close, diffuse source

Diffuse source

B

take place in varying amounts whenever light strikes the surface o our subject. If the subject is coloured certain light wavelengths wi be affected more than others; for example deep red paint absorb all colours of the visual spectrum except red, which it reflects.

Shadow quality. Because light travels in straight lines a compact ligh source produces a hard edged shadow from an object onto adjacen background. The shadow edge is even sharper when the source is long way from the subject. A diffused source of lighting illuminate the subject from many different directions giving soft, graduate shadows. The larger and closer the source, the more diffuse th shadows become (figure 3).

Strongest shadows are created by relatively small, strong source of light such as noon sun, spotlights, small flashbulbs, and othe compact lamps. Weakest shadows occur when light comes from large area source such as a totally overcast sky, or is reflected fro large white surfaces closely surrounding the subject.

Image forming. There are three basic essentials for image forming (1) an illuminated subject, (2) a method of restricting the light (e.g a hole in a card) and (3) a darkened box. Imagine that our subject is scene illuminated by sunlight, the light restrictor is a pin-hole in window blind, and the 'box' a darkened room. When a sheet of pape or ground glass screen is held to receive light from the pin-hole it i seen to show a weak image—upside down and not very sharpl defined. Moving the screen towards or away from the pin-hol makes the image smaller or larger, but it never becomes criticall sharp.

Photographs can be taken using a pin-hole (plate 6) but th dimness of the image calls for very long exposures; enlarging the hol brightens the image but also makes it less sharp. The main proble is that diverging rays of light from the subject continue to diverg

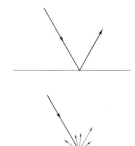

2. Above, direct reflection and, below, scattered reflection of light.

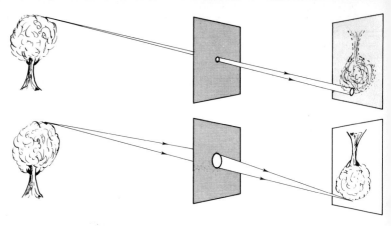

Top, image formed by pin-hole in a piece of card. *Bottom*, the effect of replacing the pin-hole with a glass lens.

after passing through the pin-hole. Any one *point* on the subject is imaged not as a point image, but as a small *patch* of illumination on the screen (figure 4). The light rays will have to be bent, and for this purpose a lens is used.

LENSES A lens is a disc of glass, ground and polished until its edges are thinner than its centre. Light from the subject meets the lens and is refracted (bent) by the glass/air surfaces so that instead of *diverging*, light rays are made to converge again (figure 4). Using this lens in place of a pin-hole the viewing screen receives a much brighter image, this time sharply resolved, although only at one position relative to the lens. In other words, the image now has to be *focused*. (This can be checked using a simple magnifying glass to image light coming through a window.)

Lenses used for photography are made up from several separate lens components. By combining various glasses and shapes, optical faults such as fringes of colour around white objects are reduced. As the elements are shaped and positioned with extreme accuracy, always take care not to knock the lens, dismantle it, or mark the glass surfaces in anyway.

Focal length. Lenses differ in their light bending power, depending upon the shapes, thicknesses, and types of glass used. The light bending power of a lens is given by its 'focal length'—in simple terms the distance between lens and image when focused for a subject a great distance away.[1]

It is worth having a set of interchangeable lenses for a camera. Typically they might consist of normal, long focus, and wide angle types. A 'normal' lens usually has a focal length about equal to the

[1] Strictly this does not apply to special designs such as telephoto lenses.

11

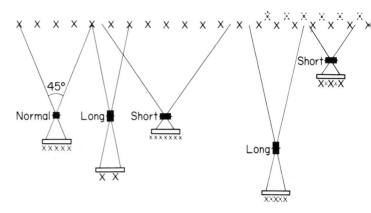

5. *Left*, the effect of using normal, long, and short focal length lenses from the same position. *Right*, using a long focus lens from a great distance includes the same amount as a short (wide angle) lens close to the subject, but gives a flattened perspective.

diagonal of the negative with which it is used, for example 8 cm. in the case of 6×6 cm. format negatives. The lens then gives an 'angle of view' of about 45°.

A long focus lens[1] gives a larger image of a distant subject than a 'normal' lens—less area of the subject is included on the negative, and therefore the angle of view is narrower. Such a lens is useful for wild life and sports photography, wherever the camera must be at some distance from the subject. A really long focus lens (say over four times the negative diagonal) appears to give a foreshortening of perspective (plate 13) as when looking through a telescope. Objects in the foreground and background of the picture are all so distant relative to the lens that they remain almost immune from perspective effects. Hence planes at various receding distances within the picture appear cramped one behind the other.

A wide angle lens has a short focal length—typically about two thirds of the negative diagonal. It gives a small image of distant subjects and is designed to fill the negative by imaging a very large area of subject matter (plate 11). Wide angle lenses are useful when working in confined spaces, e.g. photographing room interiors. As they include a great deal of immediate surroundings as well as distant subjects the viewer of the final photograph is more conscious of size diminution from foreground into background. This is usually further exaggerated by a characteristic slight optical 'stretching' of image shapes near the edges of the picture.

Quite apart from their convenience in controlling how much of a subject shall be included from the same camera position, interchangeable lenses also allow us to alter perspective without much altering the amount of subject included: for example, to steepen perspective change from a normal to a wide angle lens and then move

6. Focal length engraved around the rim of a camera lens. This lens has a 50 mm. focal length and a maximum aperture of f2.8.

[1] Long focus lenses are often loosely described as 'telephoto' lenses.

ect
nces

←A

2 fl) ←B

←C

1 fl)

1 fl)

←A

2 fl) ←B

e
ions ←C

e closer the subject
he lens, the further
nage is formed from
ns, and the larger
become.

in closer to the subject until the same subject area fills the negative. Flattened perspective occurs when we change to a long focus lens and put the camera much further from the subject.

Several special purpose lenses are made for photography. 'Fish-eye' lenses allow 180° or more angle of view, giving a circular image with distortions of form quite unknown in human vision. Zoom lenses allow focal length to be varied, resulting in a 'moving in' appearance to the image. If the lens is zoomed during actual exposure the image is blurred in lines radiating from the centre (plate C2). Interesting blurred and distorted pictures can also be made using a cheap magnifying glass instead of the camera lens.

Focusing. It is very necessary to be able to vary the distance between lens and focusing screen or film. One reason for this has been mentioned already—lenses of different focal lengths used for the same subject form sharp images at differing distances behind the lens. But even when using only one lens, *the closer the subject the greater is the distance needed between lens and film.* In other words, to photograph very close subjects we must have the ability to focus the lens some considerable way from the film.

Most amateur cameras allow the lens to be focused between limits of one focal length from the film (where it sharply focuses very distant subjects) out to about $1\frac{1}{4}$ times its focal length. Here it sharply images subjects about 5 focal lengths from the lens. More elaborate cameras allow the lens to be focused out still further— perhaps to two focal lengths, allowing a sufficiently close approach for an image to be formed exactly the same size as the subject. (See table on page 165.)

The use of lenses of different focal lengths and the ability to take pictures really close up are very important to photographers, because they bring a whole range of new visual experiences. We are able to make images with a new scale, and look at objects from angles and positions quite foreign to the human eye. Ordinary everyday objects take on a new significance—a whole day can be spent photographing a dissected cabbage or a splintered piece of wood.

Aperture (f numbers). Photographic lenses have two essential controls—one for focusing and one for closing the aperture. The focusing control (often marked off in metres) racks the lens backwards or forwards. The other control makes the aperture or 'stop' in the centre of the lens larger or smaller, and is calibrated in f numbers[1].

[1] f number is the effective diameter of the aperture, divided into the lens focal length.

A typical range of f numbers is 4 : 5·6 : 8 : 11 : 16 : 22. I changing from one f number to the next (e.g. from f8 to f11) t quantity of light passing through the lens is *halved*. Conversel changing to the lower adjacent f number *doubles* the light tran mitted.

One important feature of the f number series is that, given the sar distant subject, lenses set to the same f number *irrespective of foc length or size of camera* will all give images of equal brightness. huge 10″ × 8″ camera with its (normal) 12″ lens set to f8 and 35 mm. camera with a 28 mm. lens also set to f8 both give imag matching in intensity. This consistency is important when we con to exposure.

Some lenses are designed to open up to wider apertures (lowe numbers) than others. Lenses of f2 or less can be considered 'fas The makers usually write the maximum aperture of a lens and focal length at the front of the lens barrel (figure 6).

Lens aperture also radically influences the *depth* of subje matter which can all be sharply imaged at one time. Assuming th our subject is three dimensional, the lens at its widest aperture w often either sharply image the foreground or (at another focusi setting) the background. The lens may not, however, give a sha image of both at the same time, so that we have to compromise ar focus for some plane about mid-distance between the two. Now v move the aperture control, 'stopping down' to a higher f numbe The image not only becomes darker, but checked closely is no seen to record more foreground and background sharply. It is sa that *'depth of field'* (the distance between nearest and furthest par of the subject sharply imaged at one focusing setting) increases the lens is stopped down.

Conversely depth of field is at a minimum when the lens is ful open. Lens apertures are normally opened fully when focusir both to increase accuracy, and also because the image is visual brighter. With fairly distant subjects, depth of field extends rath further behind the critically focused plane than in front of it. good rule is to focus 'one third into the subject'.

Two further points are worth noting. Depth of field is alwa shallower when the subject is near the lens, so that special care m be taken in checking sharpness when shooting close up (see pa 166). Also a long focus lens always gives shallower depth of field th a short focus lens used under identical conditions.

Bear in mind that focusing and depth of field are visual optio The shallow depth of field offered by very long focus lenses and, wide apertures offers an important means of isolating subje

planes, of abstracting forms and colours in a way quite unlike the human eye.

The quality of a completely out-of-focus image is also interesting —its appearance differs in detail between the two sides of the sharply focused position. Notice how small bright highlights spread into discs or circles of light—these circular forms are simply due to the circular aperture in the lens. Fitting an aperture which is star shaped imposes a star form on all out-of-focus highlights. Square or triangular shapes would have similar influences.

s 6 and 7
portraits. *Left* using a
ɔle in a sheet of kitchen
ɪstead of the camera lens.
second exposure in high
sity studio lighting. *Right*
ι under identical lighting
ιtions but using a lens and
ɪng at 1/500th second at
Notice how the pinhole
a constant level of
arpness throughout,
ng being critically sharp
ιothing being critically
arp.

8
ɪotogram' produced by
ɪg a leaf between two
s of glass in the negative
ɪr of the enlarger.

Plate 9
A simple straightforward texture shot, using fine grain film and soft diffused daylight, and then printed on rather contrasty paper.

Plate 10
A multi image studio shot of a micrometer. Twenty exposures were taken on the same sheet of film and the micrometer carefully moved between each exposure. A black background is essential for this kind of photograph.

Plate 11
An industrial photograph making use of a wide angle lens and close viewpoint to give emphasis to the pipeline and exaggerate perspective. A red filter was used over the lens to darken the blue sky.

Plate 12
Movement as blur – photographed using a relatively slow exposure (1/15 second) to retain the movement of the train. The camera was supported on a tripod.

Plate 13
The Brigade of Guards, taken early one morning using a 500 mm. lens from a great distance, thus foreshortening the brigade into a very close group. Shooting under foggy conditions makes exposure estimation very critical.

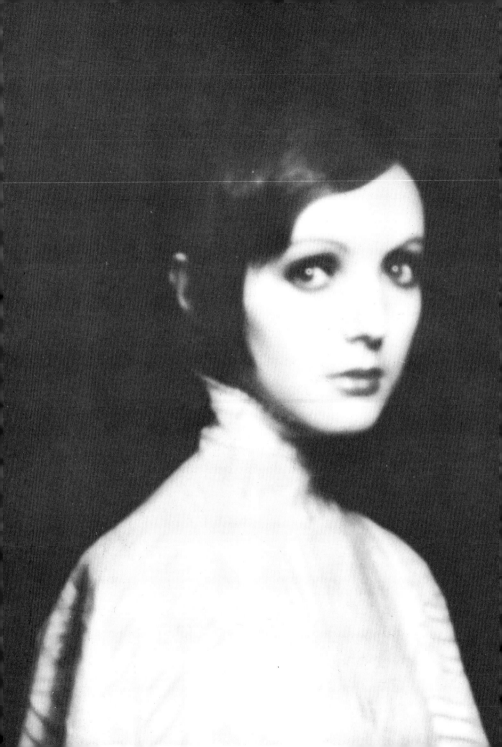

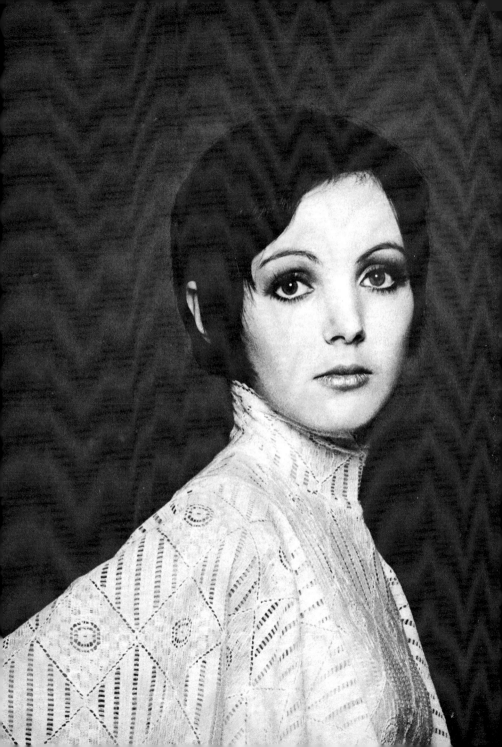

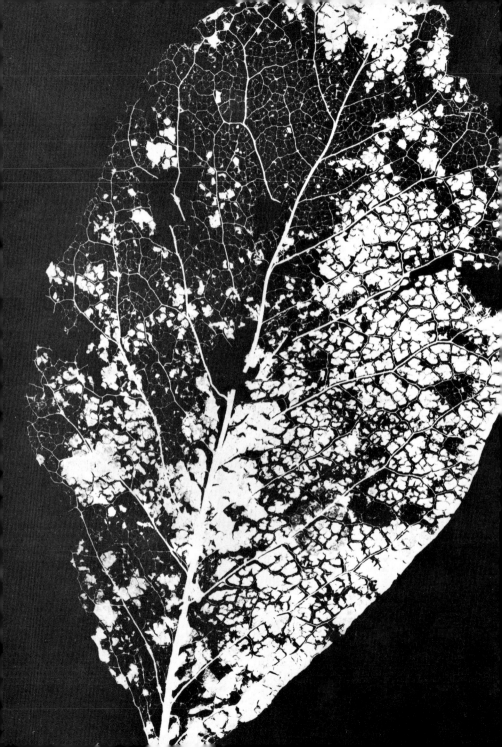

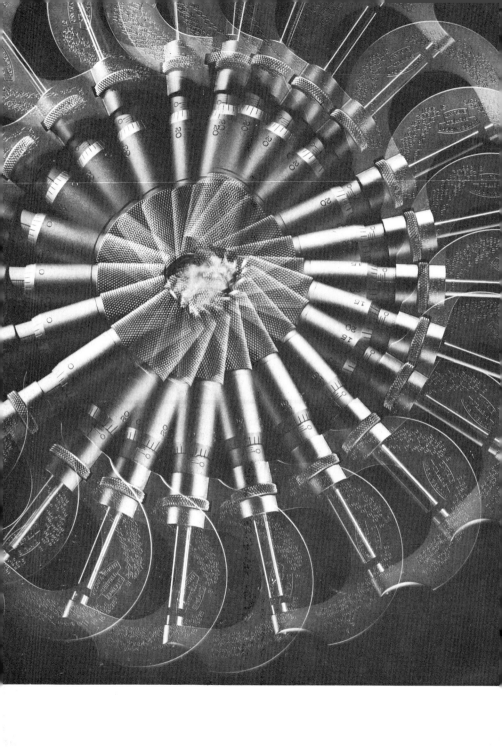

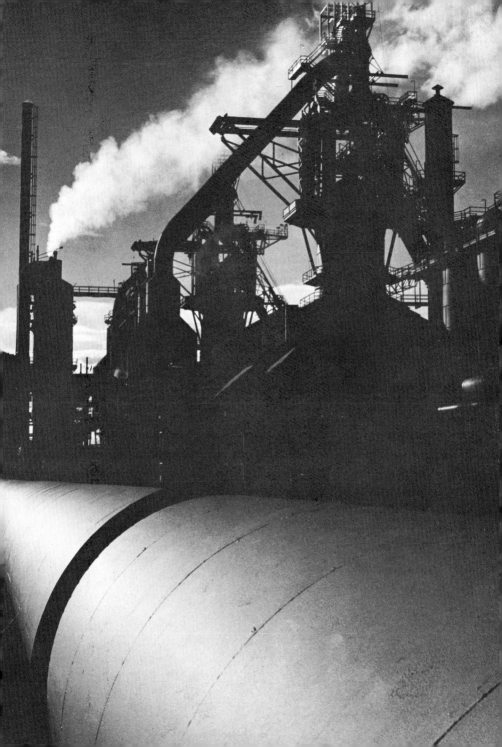

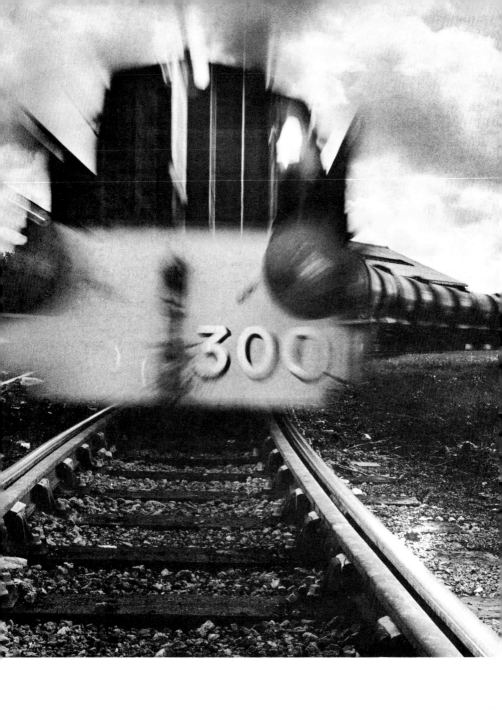

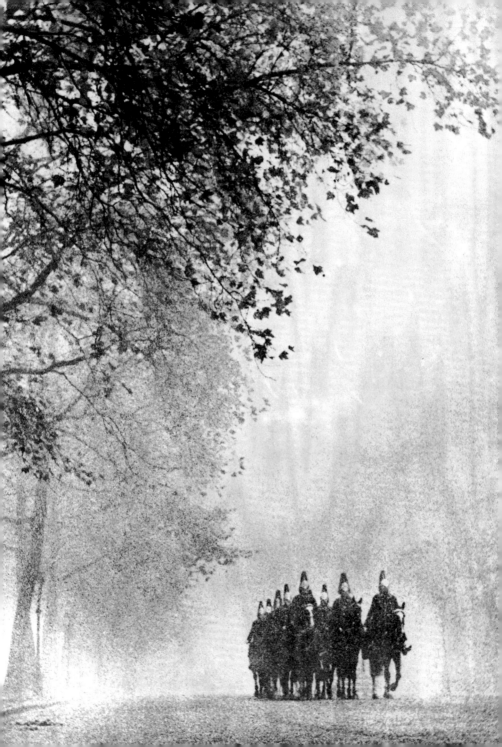

Equipment for taking Photographs

Photographic equipment is expensive and delicate compared with other hardware used by artists. Whilst it is usually sound advice to recommend buying the most expensive equipment one can afford, the technological jungle of a photographic dealer's window can intimidate even an experienced photographer. Choice must be influenced by the types of photography and handling preference as well as the money available. The aim of this section is to indicate, as impartially as possible, the various design features of cameras, accessories, and basic lighting equipment.

CAMERAS A camera is only a light-tight box with a lens at one end and a means of introducing the light-sensitive film at the other. There must also be some way of accurately focusing the lens, controlling the *time* in which light is allowed to reach the film, and giving the photographer an idea how much of the subject he is recording. Camera designs vary in the way they meet these requirements, and can be divided into four fundamental groups—direct vision types; twin lens reflexes; single lens reflexes; and sheet film (or plate) cameras.

Direct vision cameras. This type of camera has a viewfinder near the top of the body through which the photographer has direct sight of his subject matter. The Leica is probably the most sophisticated example of a direct vision camera, although many other makes exist including cameras in the lower price categories (see table I). The image format is usually 24 × 36 mm. (standard format on perforated 35 mm. film) or 28 mm. square (standard for cartridge loaded 35 mm. film) or may be 'half frame' 18 × 24 mm. giving twice as many pictures.

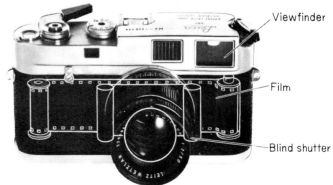

8. A direct vision type camera.

Subject seen in the viewfinder direct vision camera. frame lines show amount included by . and 28 mm. changeable lenses. rangefinder zone in centre gives an green view of the subject when the camera is correctly focused.

The camera is used at eye level. Often the viewfinder shows a 'floating' white outline denoting the picture format, at the same time showing some of the scene outside this area. The camera lens is usually focused by rotating a ring on the lens barrel—either estimating the distance to the subject and then setting the scale to the required distance, or using a built-in rangefinder. The rangefinder may be built into the viewfinder, or the photographer may have to shift his eye to a second viewing aperture. Either way the rangefinder shows two images of a small part of the subject, one usually being coloured. As the focusing control on the lens is moved one image moves relative to the other until they fuse together. The lens is now focused for that part of the subject. (See figure 9.)

The shutter (which controls time of exposure) may be a series of blades within the lens itself, or a blind built into the camera body to run just in front of the film. The latter is called a focal plane shutter, and has the advantage of serving all lenses—there is no need to buy lenses with built-in bladed shutters. One can also change lenses without fogging film already in the camera.

Changing from one focal length to another alters the angle of view, therefore the scene shown by the viewfinder in this type of camera must be masked to suit—often there are several concentric white outlines, one for each focal length.

In most 35 mm. cameras the film (which has no backing paper) is loaded in a light-tight cassette, from which film is drawn as exposures are made and wound onto a simple spool permanently housed in the camera. The winding lever also resets the shutter and operates a lock which prevents two photographs being taken on the same frame. When the end of the film has been reached *it is essential to rewind the exposed film back into its cassette before opening the camera back.* A folding handle is provided for the purpose. Cartridge loaded film (figure 20) does not need rewinding—the light-tight plastic cartridge contains *both feed and take-up spools.*

The advantages of a direct vision type of camera can be summed up as follows:

The 'floating' outline finder is particularly useful for action photography, as one can see a moving subject before it comes into frame. (See figure 9.)

Many people find that focusing by rangefinder (if fitted) is visually more decisive than by focusing screen.

The controls can be simple (even coded e.g. groups; portraits; sunny; hazy etc.) and the camera has relatively little to go wrong mechanically.

Many of the cameras of this design are relatively inexpensive.

On the other hand the physical separation of the finder and tak[ing]
lens, often by an inch or more, means that there will be differer[ces]
in viewpoint known as parallax discrepancy. This is most ac[ute]
in close-up work—parts of the intended subject are lost wh[ile]
other unwanted areas are included, and differences in viewp[oint]
give variations in the relationship of foreground to backgro[und]
parts of the picture. Also this camera does not allow the photo[gra]
pher to preview visually the depth of field achieved at various [?]
apertures, or the exact appearance of out-of-focus areas.

Twin lens reflex cameras. As the name implies, this type of cam[era]
is really divided into separate top and bottom halves each fi[tted]
with a lens of identical focal length. The lens in the top half proj[ects]
its image of the subject onto a 45° mirror and thence to a horizo[ntal]
ground glass screen. The lens in the bottom half projects its im[age]
direct onto the film (normally 6 × 6 cms. on 120 roll film).

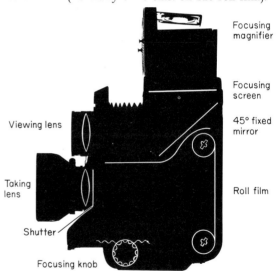

Focusing magnifier

Focusing screen

45° fixed mirror

Viewing lens

Taking lens

Roll film

Shutter

10. Twin lens reflex camera.

Focusing knob

A knob on the side of the camera focuses the two lenses ba[ck]
wards and forwards on a common panel. As the distances from [the]
lens (via the mirror) to the focusing screen and between bot[tom]
lens and the film are identical, whatever appears sharply focusec[on]
the screen will also be sharp on the film. The bottom lens has a vari[able]
aperture and a bladed shutter. The top lens simply has a fi[xed]
aperture—having the same f number as the maximum apertur[e of]
the bottom lens. Therefore the image on the focusing screen [re]
mains bright and focusing at its most critical, irrespective of whet[her]
or not the taking lens is stopped down.

The design of a twin reflex camera allows low and high viewpoints to be achieved with ease.

The advantages of a twin lens reflex are:

The focusing screen acts as viewfinder and focusing device combined.

Really accurate focusing is possible, up to and including the moment of exposure. This can be very helpful for portraiture, when subtleties of expression can change rapidly.

The camera can easily be used for very high or low viewpoints.

The larger negative format offers better technical quality when enlarged.

Against this the camera again suffers from parallax discrepancy, and allows no visual check of depth of field when the taking lens is stopped down. As the top image is once reflected it appears on the screen *reversed left to right*. This can be very 'off-putting' when panning moving subject matter, or shooting letter forms.

The camera is awkward to use on its side, therefore the normal rectangular image format used for most other cameras is abandoned for a square format, which is itself sometimes restrictive. Also every interchangeable lens has to be bought as a *pair,* and complete with shutter. A range of good lenses is consequently expensive.

Single lens reflex cameras. This type of camera uses the same lens for viewing and exposing—thereby combining the two elements of the twin lens reflex. A *hinged* mirror behind the lens reflects the image up to a horizontal focusing screen during viewing. But when the firing button is pressed the mirror moves out of the light path and a focal plane shutter at the back of the camera fires, exposing the film to the image. Immediately after exposure the mirror returns, restoring the image to the screen.

The distance between lens and screen via the mirror equals the distance from lens to film. Therefore the screen shows exactly what the film will receive. It is usual to have a pentaprism[1] block of glass over the focusing screen to reflect an upright and laterally corrected view of the image out through an eyepiece, making the camera easy to use at eye level. As a further refinement the lens can be preset for the f number required for exposure, but then remains fully open (for viewfinding convenience) until just before the moment of exposure. This pre-setting can be overriden and the lens stopped down to check depth of field visually.

Most single lens reflex cameras are 35 mm. cassette or cartridge loading, giving a rectangular picture (the pentaprism allows the camera to be used on its side). Other SLR cameras give 6 × 6 cms. images on roll film.

As a design the single lens reflex camera offers the following:

[1] Five sided.

27

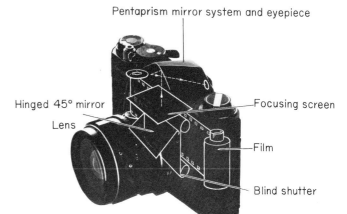

Pentaprism mirror system and eyepiece

Hinged 45° mirror

Lens

Focusing screen

Film

Blind shutter

No parallax discrepancy. Whatever appears on the focusing screen will be imaged on the film—this makes the camera very easy to use with lens extension tubes for extreme close-up work or when fitted to equipment such as telescopes, etc.

Easy interchangeability of lenses. Only single, shutterless lenses are needed.

Against this the camera is mechanically more complicated than any of the others described—it is often expensive and potentially there is more to go wrong. One also loses the image briefly at the moment of exposure. It is not a particularly convenient camera for fast moving subject matter, because the image is only seen when it is already within the frame area.

The single lens reflex is nevertheless the most versatile of camera designs, and most 35 mm. cameras in the medium and upper price bracket today are of this type.

Sheet film cameras. This type of camera is more specialized than the others discussed, gives a larger format picture (typically $5'' \times 4''$) and is intended to be used on a tripod. Mechanically it is fairly simple—not differing greatly from the old 'camera obscura'. Folding bellows connect a front section carrying the lens to a rear section carrying a $5'' \times 4''$ ground-glass focusing screen. One section can be moved relative to the other by racking it along rails. Usually the bellows are quite long, so that a very close approach can be made to the subject, particularly if a short focus lens is also used. The camera accepts a range of lenses, each one with its own bladed shutter and variable aperture.

Having composed the image on the focusing screen (we have to grow accustomed to working with an upside-down image, as mirrors

Lens and shutter

Focusing
screen

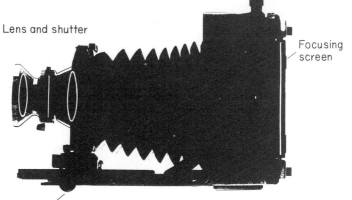

Focusing knob

and optical finders are not normally used on these cameras) the screen must be replaced with the light-sensitive film. To introduce this film into the camera a film holder or 'slide' is needed (figure 22). This is previously loaded with a sheet of film in the darkroom and sealed against light by means of a sliding sheet of stiff plastic or 'sheath'. The camera shutter, previously left open for focusing, is now closed, the focusing screen is moved and the film holder automatically located *so that its film is positioned in the place vacated by the screen.* By removing the sliding sheath the film is revealed to the inside of the camera. The shutter is then fired to expose the image onto the film, the sheath replaced and the film holder withdrawn from the camera. The holder then goes to the darkroom for unloading and processing.

Main advantages of a sheet film camera:

The relatively large focusing screen is helpful when setting up critically composed still lifes, architectural shots, or when copying artwork. The large negative is also easy to retouch by hand.

This type of camera also allows 'camera movements'—swinging or raising of front and back relative to each other. Such movements allow optical manipulation of the image and are described in Appendix II.

A wider range of film types, i.e., contrast, colour sensitivity, etc., are available for these cameras than for roll-film cameras.

Photographs can be processed individually. One can decide the degree of development for one picture alone instead of compromising between twenty exposures on a roll.

On the debit side, the camera (with its tripod and slides) is bulky and slow to use. Film of this size is more costly per exposure and the taking of many exposures on location calls for a large number of

29

slides. In brief, a sheet-film camera complements the other desig discussed, which are all essentially 'hand' cameras.

Buying cameras. It is a sound rule to buy the most expensive came we can afford, making sure that it suits our way of working a types of subjects. Take care if buying secondhand—defects ir simple sheet-film camera are quickly seen, but a complex 35 m single lens reflex can be damaged in many hidden ways. Simila lenses may have been dropped, scratched, or dismantled in wa which subtly lower their image quality. Try to buy from a reputal dealer who has overhauled the camera and will give some form guarantee. Some guides to camera books and suppliers are given Appendixes I and IV.

WORTHWHILE ACCESSORIES A small fortune could be spent on camera accessories, particula: those forming part of expensive camera systems. It is often best approach this field in terms of 'how little do I really need?' T more exotic accessories are infrequently used and best hired wh needed. Accessories selected here are given in a suggested or of priority.

Exposure Meter. Meters are near-essentials, particularly for colc photography where exposure accuracy is critical and film co high. Some cameras have built-in exposure meters, the pros a cons of which are discussed together with meter use on page More often meters are bought as separate units. The device conta: a cell which receives light and causes a needle to move across a d: This dial reading is converted into terms of shutter speeds requi at various f numbers for the film in use.

Most meters today are powered by a tiny battery (which la about a year). Other, older type meters do not need battery pov but are not quite so sensitive to very low illumination conditio

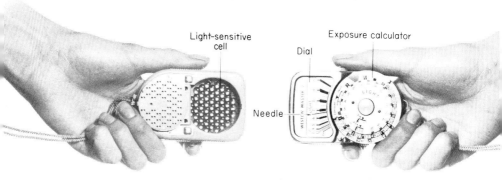

Light-sensitive cell

Exposure calculator

Dial

Needle

30

TABLE 1 A sample range of cameras—prices and types

Price Bracket[1] (1973)	Type[2]	Make	Picture Size
Up to £50	D.V.	Kodak Instamatic	28 × 28 mm.
	D.V.	Agfa Silette F	24 × 36 mm.
	S.L.R.[3]	Exa 500	24 × 36 mm.
£50–£100	D.V.	Minolta AL-F	24 × 36 mm.
	S.L.R.[3]	Practica	24 × 36 mm.
	T.L.R.	Yashica-mat	6 × 6 cm.
£100–£200	S.L.R.[3]	Pentax	24 × 36 mm.
	D.V.	Vitessa 1000 SR	24 × 36 mm.
	T.L.R.	Rolleicord	6 × 6 cm.
	S.F.	Gandolfi Precision	5 × 4 in.
£200–£300	T.L.R.	Rolleiflex 'T'	6 × 6 cm.
	S.L.R.[3]	Nikon	24 × 36 mm.
	D.V.(R)[3]	Leica	24 × 36 mm.
	S.L.R.[3]	Pentacon	6 × 6 cm.
	T.L.R.[3]	Mamiyaflex C33	6 × 6 cm.
	S.F.[3]	Arca	5 × 4 in.
Over £300	S.L.R.[3]	Hasselblad	6 × 6 cm.
	S.F.[3]	Sinar	5 × 4 in.
	S.L.R.[3]	Leicaflex	24 × 36 mm.

A meter must be accurate and reliable—film and time spent re-shooting soon outweigh its cost.

Tripod. This is very necessary if shutter speeds of longer than about 1/30th second are to be given without camera shake; also to support a stand camera. A tripod is intended to give firm support, so it is pointless to buy a frail lightweight model which can never be fully trusted, just because it is lighter to carry. Tripod strength must be judged against the size of camera. It should allow easy vertical adjustment (a centre column is much quicker than adjusting all three

[1] Applies to new cameras. Second-hand values about 25% less, subject to age and condition.

[2] S.L.R.: single lens reflex; T.L.R.: twin lens reflex; D.V.: direct vision; D.V.(R): direct vision with coupled rangefinder; S.F.: sheet film plate camera. All cameras include standard lens.

[3] Accepts interchangeable lenses.

eneral purpose
ure meter, front
ack.

15. Methods of increasing the distance between lens and film. Extension rings (top) or bellows (bottom) are attached between the camera body and lens.

legs) and make possible very *low* as well as high viewpoints. A 'p... and tilt head' for the tripod is essential, as this allows the came... to be pointed around in almost any direction once the tripod is firm... set up.

Cable release. Pressing the shutter release button easily jogs t... camera, even when it is mounted on a tripod. A cable release on... costs a few shillings, screws into a special socket on or near t... release button, and gives a smooth action rather like cable brakes ... a bicycle. Releases are made in various lengths from about 2″ to... yard or more. Ten to twelve inches is a convenient size.

Extra lenses, and extension tubes. If our chosen camera allows inte... changeable lenses the purchase of a second lens obviously wide... its scope. Assuming that the first lens is a 'normal' for the size ... negative, the next most useful lens is likely to be a wide angle. ... the same time extension rings or bellows greatly extend the poss... bilities of either lens for close-up work if the camera has limit... focusing movement.

Lens hood. Like a sun visor in a car, a lens hood is intended to blo... light from just outside the picture area. This reduces general lig... scatter which otherwise gives a low contrast, flat image—partic... larly when the subject is backlit or has large, light-toned surroun... ings. Most lens hoods do double duty as filter holders by acceptin... discs of coloured gelatine or glass (colour filters, see pages 55 & 14...

LIGHTING
EQUIPMENT

Tungsten lamps[1]. Mains operated tungsten lamps for photograph... fall into two main categories—floodlights and spotlights. A floo... is designed to give a large area of even illumination and soft edge... shadows. It therefore has a large (often white painted) bowl reflect... containing a 500w or 1000w 'photographic' lamp. A cheaper altern... tive, a 'photoflood' lamp, gives out more light but has a muc... shorter life. Some floodlights use the more compact tungsten haloge... (or 'Quartz Iodine') lamp, which does not blacken as it grows olde...

A spotlight unit consists of a lamp with a compact filament set ... in a lamphouse with a lens at the front and a reflector at the bac... Turning a control on the outside focuses the lamp relative to the len... At one focusing extreme the lamp forms a broad beam of light as ... from a point source, giving very hard, sharply defined shadow... At the other focusing limit the spotlight gives a smaller but mo...

[1] Lamps using a filament of tungsten metal heated by electricity—the househo... lamp is one example.

32

A focusing spotlight.

A 500 watt floodlight stand.

intense area of light with strong but more soft edged shadows. As a cheaper alternative to focusing spotlights, sealed beam spotlamps can be used. These are similar to car headlamps, and the lighting unit need be little more than a simple lampholder.

Direct use of spotlights can emphasize texture and form, but creates intense shadows in which detail may not record unless lightened by means of a flood or large white reflector. Spotlights are more expensive than floods, but can be made to give illumination of similar quality to a flood by 'bouncing' (reflecting) off a suitable surface such as a ceiling or white wall.

Spots and floods are severely limited unless provided with floor stands or supports of some kind. These should allow easy adjustment up or down. Accessories include 'barndoors' to prevent light spill in selected directions, cone shaped 'snoots' to give small pools of light, and holders for coloured acetate filters.

Flash. As a light source flash must be divided into two types—traditional flashbulbs and the more modern electronic flash. Flashbulbs consist of inflammable metal enclosed in a glass envelope and ignited by electricity. The metal burns out in a brilliant flash lasting 1/50th—1/100th second. Only about 3 volts is needed for firing, and this is supplied by a small battery system, connected through contacts in the camera shutter. The flashgun is therefore connected to a nipple on the camera shutter (usually coded 'M' or 'FP'). As the shutter begins to fire the internal contacts come together in time for the bulb to reach its maximum illumination whilst the shutter is fully open. Flashguns are fairly cheap but, as bulbs can be used once only, running costs can be high. The small size of most modern flashbulbs creates a very hard light source unless diffused or bounced.

Electronic flash produces light from a gas-filled tube through which a high current is briefly discharged. The flash lasts about 1/250th—1/2000th second, and as thousands of flashes can be obtained from the same tube running costs are very low. However, the power-pack required is more complex than for flashbulbs, and it can be quite bulky and expensive if the flash is powerful. Relatively low output flash outfits are small enough to fit wholly on the camera; medium powered units require a shoulder harness for the power-pack; and powerful studio units have large electronic consoles. The firing lead of the flash units plugs into the shutter socket marked 'X' so that the flash fires when the shutter is fully open.[1]

[1] In the case of focal plane shutters it is usually necessary to set the shutter to 1/30th sec. or slower—this may be colour coded on the setting dial.

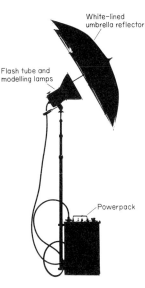

White-lined
umbrella reflector

Flash tube and
modelling lamps

Powerpack

Electronic flash designed for the studio normally uses main electricity and may have a 100 watt tungsten lamp mounted close to each flashtube. Illumination from these modelling lamps is sufficient to show the photographer the effect of his lighting in terms of shadow casting, evenness etc., knowing that when he fires the shutter the flash will give identical quality but in a fraction of a second.

Flashtubes are made in a range of shapes, from compact forms which give hard lighting, to strips and grids several feet long and therefore giving very diffuse lighting. The main limitation to this important and versatile light source is its capital cost.

18. A studio electronic
flash unit.

CHAPTER 3 Films for Black & White Photography

For over 100 years photography has been linked with the metal silver. The films and papers we use are coated with silver salts (silver halides such as silver bromide, silver iodide, or silver chloride) because such salts undergo physical and chemical changes when exposed to even quite small quantities of light. Nothing has yet been found to equal silver in terms of sensitivity and final image quality. This is perhaps a pity, for a world shortage of silver has made prices high and the cost of photographic materials correspondingly expensive per unit area.

Manufacture. In order to attach silver salts (or 'grains') to a film or paper base the manufacturers first mix chemicals into a solution of gelatine; the combination is known as a silver halide emulsion. While making the emulsion chemists add various trace elements to control its overall sensitivity or 'speed' and its reaction to various colours.

The warm creamy coloured emulsion is mixed in the dark and coated (still in the dark) onto rolls of cellulose acetate or high quality paper. This is then chilled and dried. Emulsion may be coated on glass to give 'plates', or on various plastics, linen tracing cloth, and a few other practical materials. The coated rolls then go for slitting up and cutting into the various standard sizes. (For the moment we shall be looking at black & white films, leaving details of papers and colour materials until Chapters 6 and 7.)

How films work. From the time of manufacture until the moment of exposure in the camera the film is stored carefully away from damp, fumes, and actinic light (i.e. light to which the emulsion is sensitive). Exposure to image light causes a few atoms of black silver to form in some silver grains—roughly in proportion to intensity, so that more atoms are formed in highlights than in shadow areas.

However, such minute changes are quite invisible to the eye—if we took the exposed film out into the light at this stage it would look the same creamy colour as before exposure. In practice the film carrying its latent (invisible) image is kept in the dark until it can go into a developer solution. The developer contains chemicals capable of amplifying these minute specks of silver several million times. During development the grains affected by light become deposits

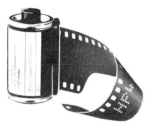

19. A 35 mm. film in a cassette.

of black metallic silver which, although still small individuall collectively form areas of visible tone.

Still in the dark, the film is next placed in a fixing solution whe the silver halides, unaffected by image light and therefore virtual unaffected by the developer, are removed. The film loses its crean appearance, and when the lights are switched on should be four to carry a black image on clear acetate film. This image appea 'negative'—that is, the lightest areas of the camera image ha caused greatest deposits of black silver, and darkest areas least.

When the film is washed and dried it is easily placed in conta with a sheet of silver halide emulsion coated paper (or film if a tran parency is required) which is then exposed to light. A similar pr cessing cycle follows, resulting in a *positive* image (a negative ima of the negative). This positive accurately records the original came image in terms of monochrome—representing highlights ligh shadows dark, and intermediate tones and actinic colours pr portionally as greys. But printing itself will be discussed in mo detail in Chapter 6. We should first return to the physical film itsel

FILM CHARACTERISTICS

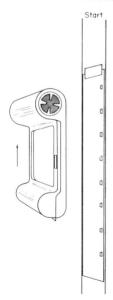

Start

20. A plastic 'quick load' cartridge, and the 35 mm. film and backing paper it contains.

Sizes and packaging. Recent years have brought a welcome co traction in the number of film sizes on the market—the vast majori of cameras today take either (a) 35 mm. wide film, or (b) 6·4 cm $(2\frac{1}{2}'')$ wide roll film, or (c) sheet films.

(a) 35 mm. film perforated down both edges, sold in metal plastic cassettes containing sufficient film for 20 or 36 exposur each 24 × 36 mm. (or an equivalent greater number of smaller fo mats). Most photographers use cassettes once only—throwir them away after removing their contents in the darkroom for pr cessing. It is however possible to buy just the 35 mm. film in reloa lengths or bulk tins (5, 10 metres etc.) Thus with time and care it possible to save money by reloading cassettes.

35 mm. film is also marketed loaded in 'cartridges' (usually givir 12 exposures 28 × 28 mm.) for 'quick loading' cameras. The fil has only one perforation per exposure which marries up with sensing claw in the camera, so that the film is moved by one fram after each exposure. The point of an easy load cartridge is that contains both the feed compartment and take-up spool in one un (figure 20) ready to drop into the back of a suitably designed camer After all the exposures are made the plastic cartridge is just remove from the camera, taken into the darkroom, and broken in half remove the film for processing.

(b) Roll film. Roll films 6·4 cms. wide (often coded 120, 620, or 22 depending upon detail such as the shape of the spool or length

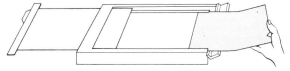

Start

21. A roll film, showing how the light-sensitive film is attached by its leading edge to the backing paper.

End

film) are today mostly used for cameras giving 6 cm. square pictures. Roll films are normally unperforated, long enough for 12 exposures (or 20 exposures 220), and use backing papers for loading without fogging (figure 21). The film is supplied on a familiar flanged spool and after loading into the camera winds onto an identical take-up spool. Since the backing paper is longer than the actual film, the camera can be opened after shooting the twelve pictures and the now full take-up spool removed without fogging. The empty feed spool is swopped over to become the next take-up spool.

(c) Sheet films. Sheet films are made in a range of sizes from $6 \cdot 5 \times 9$ cm. to 30×40 cm., see table 2. The most common of these is $5'' \times 4''$ ($10 \times 12 \cdot 7$ cm.). Films are packed in boxes of 10 or 25, each sheet interleaved with black paper. To help locate the emulsion side when loading film holders in the dark each sheet of film is notched—the notch should be at the right hand side of the top edge when loading a holder vertically.

Film speed. 'Speed' is the term used to describe the general sensitivity of the film to light. More specifically each film type is given an ASA[1] (or DIN[2]) speed rating in numbers which are related to light sensitivity. A film with a rating of 20 ASA is considered very slow; a 160 ASA film is eight times as fast and therefore requires only one eighth of the exposure level (e.g. the shutter can be set to one eighth of the previous exposure time *or* aperture stopped down by three f numbers). A film of 1000 ASA is today considered fast (see table 2). ASA speeds are clearly stamped on the film box, and must be set on the exposure meter. (Warning: These figures indicate the *maximum* practical speed of a film under normal development conditions. Many photographers purposely under-rate films to 1/2 or 2/3rds normal rating to obtain greater insurance against under-exposure.)

One might assume that it would be good practice always to use the fastest films, in order to be able to give a very short exposure time to avoid subject movement, and/or to stop well down for depth of field. In practice fast films are sometimes an embarrassment—for example if shooting in very bright lighting conditions, yet needing shallow depth of field or blurred movement. (See plates 12 & 27.)

A sheet film holder g loaded in the kroom.

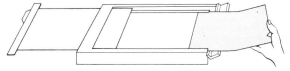

[1] American Standards Association.

[2] Deutsche Industrie Norm (German Industrial Standard).

Grain. As a general rule very fast films are fast because they have thick emulsions containing relatively large silver halide grains; slow films have much smaller grains, which may be coated quite thinly. Given the same development the fast film will have the grainiest image—detail will visually break up into a 'mealy' pattern at a lower magnification than the slow film.

There are many fine grain developers on the market, but although they do help to minimize inherent graininess, the appearance of the final image is always more dependent upon the original emulsion structure than the processing solution. (See plates 1 and 44.) Film manufacturers are constantly striving to increase film speed without increasing graininess.

For practical purposes it can be assumed that most black & white films of less than 125 ASA are very fine grain, films of about 125—400 ASA are moderately fine grain and films of 1000 ASA and over are relatively coarse grain. Therefore any photographic subject demanding highest image resolution (fine texture for example) should be shot on fine grain film, despite its slow speed.

Other contributory effects on final image grain—such as developer and degree of development—are discussed in Chapter 5.

Film Contrast. A film having a low contrast emulsion is able to record a much wider range of grey tones between black and white than a high contrast film. Used to photograph identical full tone range scenes the first film gives a 'flat' negative; the second film gives a 'hard' negative with few discernable greys between dense black and clear white.

All the films sold for general photography are relatively low in contrast, the slower films having slightly more contrast than fast films (assuming normal development in each case). The resulting slight differences between negatives are more than adequately compensated for by printing papers, which are made in a wide range of contrast grades. Thus a flat negative may be printed on a hard grade of paper, to give a result similar to that from a hard negative on a flat grade of paper.

Very high contrast sheet films (e.g. 'line' and 'lith' materials) intended to record images as solid black and clear white, are useful for copying black & white artwork such as letter forms, ink drawings and engravings, because they emphasize separation between ink and white paper which might be degraded on normal contrast film. High contrast emulsions tend to be fine grained and very slow, with speed around 5—20 ASA. Owing to their slowness and limited colour sensitivity it is not often practical to photograph animate

subject-matter direct onto these emulsions to get a high contrast effect. Such subjects are more conveniently photographed on faster, normal contrast film, and subsequently printed onto line film in the darkroom to give a high contrast intermediate.

Colour sensitivity. About 99% of all black & white films used in cameras today are 'panchromatic', a term meaning that they are sensitive to light of all colours in the visual spectrum. Colours are recorded as greys which (in the final print) approximate the relative 'brightnesses' of colours seen by the human eye, e.g. greens and yellows lighter than deep red or purple.[1]

When loading film holders or processing panchromatic materials in the darkroom it is not safe to use a 'safelight' of any colour.

Some sheet films and one or two 35 mm. films are made with 'blue sensitive' (also known as 'ordinary' or 'non-colour sensitive') emulsions. They are intended for jobs such as copying monochrome artwork or making black & white slides from existing negatives. Most black & white printing papers are blue-sensitive only. The main advantage of blue-only sensitivity is that materials can be handled under fairly bright orange safelights during loading, processing etc. Panchromatic line films are available for copying multi-coloured line artwork, and panchromatic printing paper for making monochrome prints from colour negatives.

A few photographic materials (e.g. Kodalith) are made with 'orthochromatic' colour sensitivity—a term denoting that the emulsion responds to all colours except red. Orthochromatic films can be handled in the darkroom under *deep* red safelighting.

To sum up, as table 2 shows, the differences between various branded photographic films for black & white negatives can be broken down into physical size, colour sensitivity, speed, grain size, and contrast. Film manufacturers find little demand to per-mutate all these variables fully and the current professional catalogues should be checked to see what combinations are available.

SPECIAL BLACK & WHITE CAMERA FILMS

Reversal film. It is possible to process a camera exposed film direct to a *positive* black & white image instead of a negative. The result is a positive transparency which may be projected as a lantern slide, or used to print negative images on paper. Most conventional negative films (e.g. Plus X, and Ilford line film) can be used, and given an extended sequence of 'reversal' processing.

[1] Most panchromatic emulsions slightly distort, finally reproducing blues too light in tone. If considered important, correction can be made using a yellow filter on the camera.

TABLE 2 A sample range of films for black & white photography (1970)

Speed	Brand name	Grain	Main uses
ASA 12	Ilford N5.31	Very fine	Monochrome copying and printing work (non colour sens.).
32	Kodak Pan X	Very fine	General work wherever the image must remain grain-free despite great enlargement.
125	Kodak Plus X	Fine	Still life and general subjects when lighting and subject (movement) are favourable.
200	Ilford FP4		
400	Kodak Tri X	Medium	General subjects—studio and location.
800	Agfa Isopan Record		
800	Ilford HP4		
1250	Kodak Royal X Pan	Coarse	Very dim lighting conditions or when grain pattern required.
2000	Kodak Type 2475 Recording Film	Very coarse	Emergency use—very limited tone range.

Sheet Film—Popular Stock Sizes

Non Metric (becoming obsolete)	Metric
$3\frac{1}{4}$ in. \times $4\frac{1}{4}$ in. ('quarter plate')	$6·9 \times 9$ cm.
4 in. \times 5 in.	9×12 cm.
$4\frac{3}{4}$ in. \times $6\frac{1}{2}$ in. ('half plate')	18×24 cm.

A few films such as Agfa-Gevaert 'Dia-Direct' 35 mm. film are specifically intended for reversal work. After exposure the film can be sent back to the makers where it is reversal processed and returned ready for projection.

Polaroid Land black & white film. This patented process allows a finished positive print to be pulled from the camera a few seconds after exposure. The film is either used in specially built cameras, or in Polaroid backs designed for use with existing $5'' \times 4''$ sheet film cameras and some roll film types.

In all cases the material consists of a light-sensitive emulsion on film (or paper) which is exposed to the camera image and placed in face contact with a white receiving paper. Spring rollers break a 'pod' of jellied chemicals attached to the film, spreading its contents between the two layers—whereupon they process up a negative image in the light-sensitive emulsion and cause a black positive image to transfer to the receiving paper. After a few seconds the two materials are peeled from the camera, the receiving paper carrying an immediately usable print.

Polaroid Land materials are particularly useful for quick checks on exposure and lighting, and for layout purposes. The image quality obtainable is excellent but cost per exposure is about six times the cost of equivalent conventional film. Polaroid produce a similar colour material (Chapter 7), but this is even more expensive.

CHAPTER 4 # Shooting in Black & White

From the beginning we should recognize certain differences between the eye and the camera, in order to previsualize photographically:

1. The camera does not itself discriminate between wanted and unwanted parts of the subject. Every part of the image shown in the viewfinder or focusing screen should be meticulously assessed before exposing, *preferably at the lens aperture to be used for shooting.* This is because stopping down increases depth of field, making unwanted items in the foreground or background much sharper than they may have appeared on the focusing screen at wide aperture. (Most single lens reflexes with automatic diaphragms have a manual over-ride for previewing depth of field at the chosen f number.)

2. Photographic film cannot record a very wide of range of brightnesses present in the same scene. Our eyes may distinguish detail in both shadows and highlights of a strongly lit subject, but a photograph often fails to record image information in either or both of these extremes. The maximum range black & white film can handle occurs when highlights are about 100 times brighter than shadows. Range can be checked by exposure meter (as described later). In general one can assume that the photograph will exaggerate lighting contrast, and if full detail everywhere is required the subject should be illuminated less harshly than appears correct to the eye. This might be done by using white reflectors to introduce more illumination into the shadows. Alternatively, *unwanted* detail in highlights or shadows can be suppressed by purposely over or under lighting these areas (plates 19 and 28).

3. Colour contrasts which to the eye clearly separate various elements in a scene may be almost indistinguishable in a monochrome photograph. A typical example: a red object stands out markedly again similar green objects, but both colours may finally reproduce in near-identical grey tones. We therefore have to attune ourselves to exploit differences in subject forms and textures rather than differences in their colours (although filters can help to exaggerate colour separation, page 55).

4. Photography has to turn three dimensional reality into a two dimensional still picture (stereo and movie cameras excepted). Receding tone planes, converging lines (perhaps exaggerated by close viewpoint), and shallow depth of field are all useful aids here.

14
otograph for an
tisement promoting the
of colour TV – the
n read 'Black and white
dead'. Having found a
le location, the picture
hot at dusk on Royal X
lm, using professional
ls. The wide angle lens
sed to emphasize
ective.

43

Movement has to be symbolized by blur achieved by longer than normal exposure times, or 'chopped up' into a frozen overlapping sequence by means of a stroboscopic light source[1] or a fast repeating shutter.

5. Photography isolates a moment in time. With the obvious exception of still-life subjects the photographer's choice of the moment to fire the shutter is crucial. Few modifications are possible to an image after exposure. All the most important visual decisions have to be predecided—relationship of subject to foreground and background, depth of field, sharpness, expression and stage of action, perspective and lighting. We have to be able to make all these visual variables work *for* us instead of being purely fortuitous. suppose the simile in learning to drive is braking, changing down, checking the road behind, steering, and swearing at the other driver all at the same time. It grows easier with practice.

SETTING UP IN
THE STUDIO *The studio itself.* Paradoxically, many photographers like to use studio from which all external light can be excluded. Natural lighting in Great Britain is so variable in intensity and quality that much of the time tungsten or flash lighting is used instead—and to fully control these artificial light sources all other illumination should be suppressible. At the same time a large north facing window which can easily be blacked out is also useful.

Choice of a room for a studio naturally depends upon the type of subjects to be tackled. If photography is to include full-length figure shots bear in mind the longest focal length that will be used on the camera. The narrower the angle of view the greater distance needed between camera and subject, see table 3 below. Also allow for space *behind* the figure—the roll of background paper should curve away sufficiently to be lit separately and should also allow room for lights at the sides to back-light the subject. A high ceiling is

TABLE 3 Angle of view and subject distance

| | | | Lens-to-Sitter Distance (Metres) | | |
| Negative | Lens | Angle | Needed to Include | | |
Format	Focal Length	of View	Head	Half Length	Full Length
6 × 6 cm.	80 mm.	45°	0·4	1·1	2·4
5 in. × 4 in.	150 mm.	45°	0·4	1·1	2·4
24 × 36 mm.	55 mm.	40°	0·5	1·2	2·7
6 × 6 cm.	180 mm.	20°	1·1	2·5	5·5
24 × 36 mm.	135 mm.	18°	1·3	3·0	6·3

[1] A lamp flashing repeatedly at high frequencies.

a great advantage as this allows shooting downwards from the top of a ladder or, by enabling the background to be raised really high, allows shooting from a very low viewpoint.

On the other hand a studio used only for modest still life sets can be as small as an ordinary living room. Try to avoid rooms which are odd shapes (a square floor plan is least restrictive), and rooms with springy floorboards which so easily give camera shake when making time exposures.

Walls and ceiling should preferably be painted with matt white emulsion paint. This gives an excellent diffuse reflection surface so that when necessary we can 'bounce' spot and floodlighting to achieve soft overall illumination. If redecoration is not possible make up large skeleton screens (figure 23) from wooden battens, and staple on sheets of white paper. The screens can then be used locally around the subject area if required.

A large lightweight
den reflector screen
with white paper.

All lighting units should have leads long enough and power points frequent enough for all lamps to be used in any part of the studio. All power points must be at least 13 amp three pin for safety (13 amps allows up to 3,250 watts at 250 v). Finally, don't overlook ventilation. Small studios quickly get fuggy, and even large ones can become very warm from tungsten lighting during long sessions.

Organizing a simple still life. A simple studio still life is the most useful sort of subject to choose when starting photography. Providing your camera allows fairly close working, a still-life composition is of great value in teaching the use of lighting, viewpoint, and technicalities of exposure. Once it is set up one can go back again and again, improving technique or developing visual ideas.

Start out with a really generous area of background, whether it be fabric, matt paper, or just the floorboards. If paper, take the greatest care to avoid kinks, folds, or dirty surface marks. Having laid the paper out flat on a surface such as a table in the centre of the studio, the rear of the sheet can be curved upwards against a suitable support so that when the camera looks down on the set the surface appears continuous. Choice of background colour and tone is obviously influenced by the subject itself, but grey or white are the most useful as the rear areas can then be made to appear any tone between white and black, according to the intensity at which they are lit relative to the main subject.

Having made a rough arrangement of main subject and props (if any) build up the lighting *one unit at a time.* For example, if textures are dominant begin with a spot or flood direct, watching the subject planes whilst the unit is moved 360° around the set, and again at

45

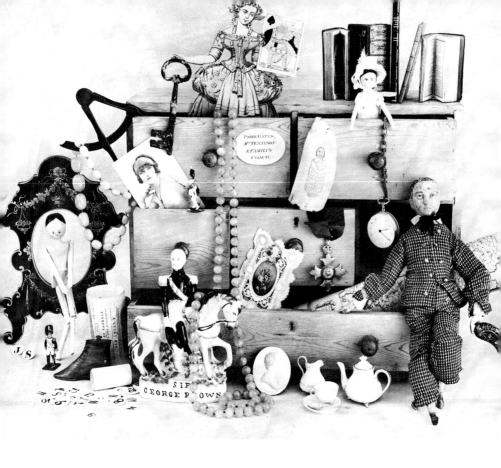

Plate 15
A still life editorial illustration. Multi object arrangements such as this require soft, even lighting. A great deal of trouble is taken over the combinations and positioning of elements so that items are in sympathy with one another and work successfully as a whole.

Plate 16
Still life in reflected daylight, the only additional light being a mirror to throw a highlight onto the glass.

Plate 17
Still life of apples – an illustration for an article on pollution. The lighting was by diffused daylight through a sky light, and a 5 × 4 camera was used to give maximum detail.

Plate 18
Another still life filled wi many shapes and forms a through large sheets of diffusing material. A larg format (5″ × 4″) camera is suited to this type of pict because of the extra imag quality it can produce.

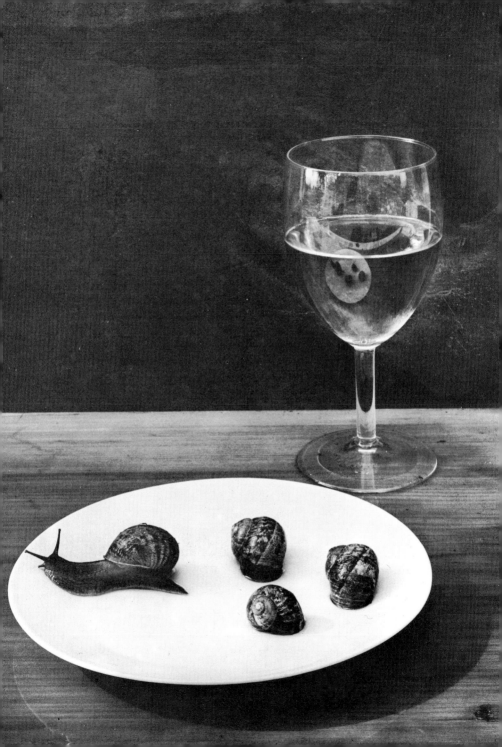

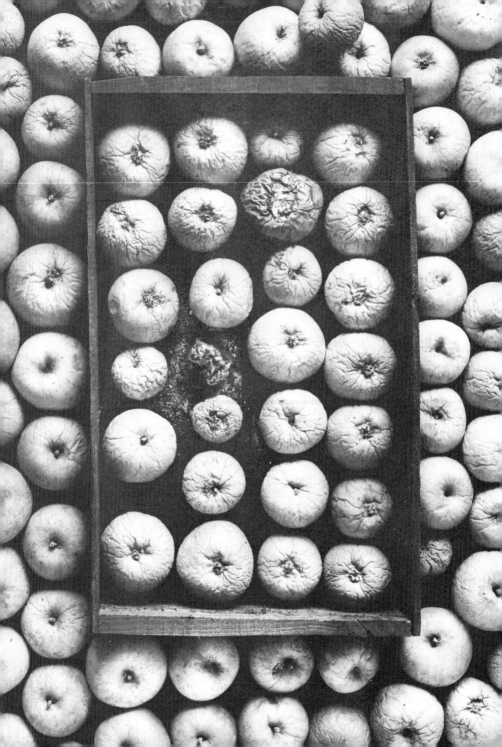

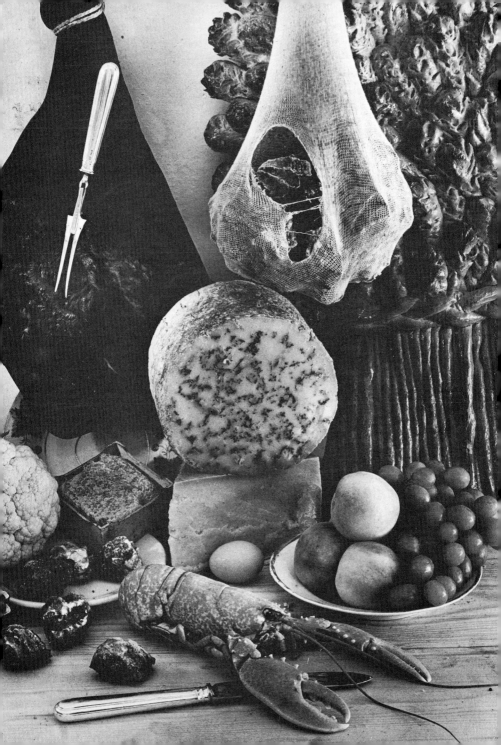

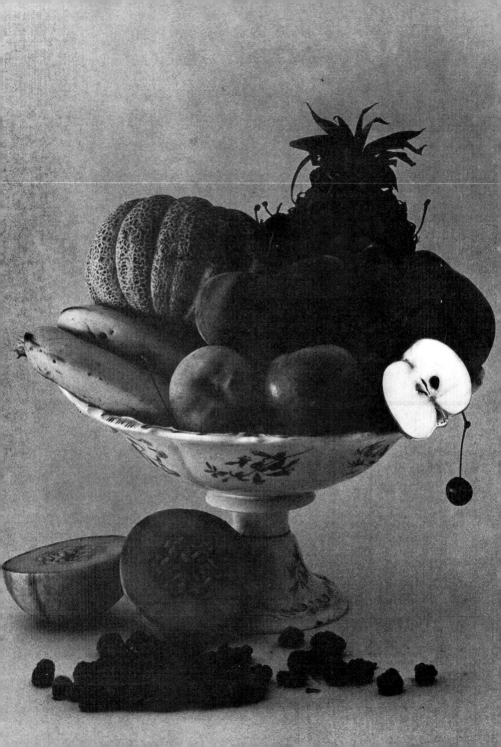

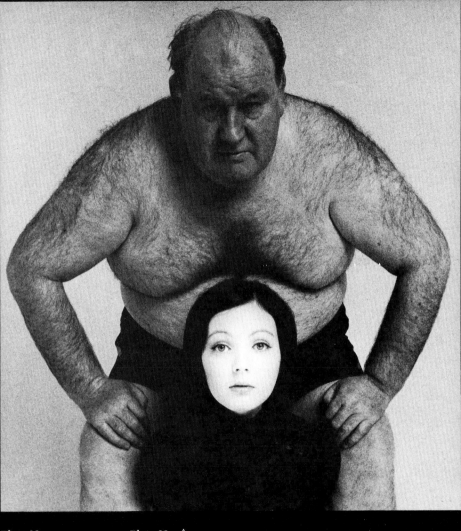

Plate 19
An editorial illustration
of fruit using a lighting
technique similar to
plate 16.

Plate 20 △
Wrestler and child. In
this photograph the
lighting has been used to
strengthen the characters
in the photograph, i.e. a
soft diffused spotlight
was used on the child
only, plus a large
diffused light overall.

various heights. For the most hard dramatic lighting use a spot light low, from the rear, and some distance from the set. Placing the set in the centre of the studio pays off here—we are free to light the subject from any direction, even from the rear.

All the foregoing can be carried out without having the camera present, but now with this 'key' light established it is helpful to start looking through the camera itself. Don't let the camera become a psychological barrier between photographer and subject. Having this machine in the way, with its various controls, tripod etc., is at first inhibiting; but don't let the camera control you.

Where practicable it is helpful to start off with the camera *in the hand*—this facilitates experiments with all sorts of angles and view points. Only when the most successful position has been chosen bring up the tripod to support the camera. Avoid just using the camera at a convenient height, or all your still lifes will be shot at monotonous 30° downward-looking viewpoint. If the camera needs to be very high re-establish the set on the floor. Remember also focal length—to steepen perspective change to a wide angle lens and move in closer.

Having established the camera position and if necessary re-adjusted the keylight, some form of secondary lighting will probably be needed to lighten the shadows. This has to be organized with care or further shadows will be formed by the new light source. With a small set much can be done with a large white reflector near the camera, to reflect back some split key light. Alternatively additional lights can be pointed at convenient wall, ceiling, or screen surfaces. Provided the reflective surfaces are large enough and fairly close, virtually 100% diffuse lighting will reach the set, adding detail to shadows without forming unwanted new ones. (See plate 20.)

Further lights can now be added where necessary to give emphasis to important surfaces, or lighten the background. Never use more light sources than are absolutely necessary. Over-complicated lighting produces a tangle of shadows which may effectively camouflage subject form.

Now check the image at various lens apertures, watching with great care to see which zones grow sharp, and at the same time looking out for shortage of background, and odd reflections or blemishes which are too out-of-focus to be seen clearly when the lens is fully open. If depth of field does not extend through the required subject planes even at smallest aperture the situation may be improved by moving back from the subject or using camera movements (see page 166).

Unless a photographer specializes in a narrow field of work and knows his studio conditions intimately it is impractical to guess the shutter speed and f number required for correct exposure. Film is expensive and wasted time even more so—therefore the purchase of an expensive meter is fully justified.

Literally hundreds of exposure meters are marketed. They can be categorized into three main forms—The separate self-contained meter; the meter which is built into (or clips on) a particular camera; and meters specially designed for measuring exposure with flash illumination.

Measuring with a separate meter. The self-contained meter (figure 14) comes in various physical forms and the user can hardly do better than read the instructions for his particular make. In the absence of an instruction book the soundest way of taking a reading is to measure separately the subject's darkest *important* shadows and lightest *important* highlights.

First select these darkest and lightest areas where detail should still record in the photograph. The meter's measuring cell is pointed at the two areas in turn. If the area is small the meter may have to be held only an inch or so from the subject to avoid including unwanted parts of the subject or lights at the same time. Take care that the meter does not itself cast a shadow on the area measured.

The two readings are averaged—for example if shadows read 8 and highlights 10, 9 is taken as the reading. Having reached this stage most meters require the reading on the dial to be transferred to a calculator disc on the meter body. This disc is first set for the speed of the film in use (the ASA or DIN number stamped on the carton). When the reading from the dial is placed opposite an arrow or similar marker the calculator shows the combinations of shutter speed and f number required to give correct exposure. All these combinations of time and image intensity give virtually the same exposure level, e.g. 1 sec. at f22; $\frac{1}{2}$ sec at f16; $\frac{1}{4}$ sec. at f11 etc. It is up to us to decide which one of these combinations is the most appropriate, bearing in mind other considerations such as depth of field, and subject movement.

For example, when shooting a still life subject with the camera on a tripod, we are not really concerned about camera shake or subject movement, and so have an unrestricted choice of shutter speed. But the effects of f number on depth of field are important. If it is desirable to have as much subject depth as possible sharply rendered we would choose the smallest aperture the lens offers. The *aperture* in this case is therefore decisive, and the shutter speed chosen is the

one opposite this f number on the meter.

If the time indicated is longer than 1 sec. (the longest shutter spee offered by most cameras) the shutter will have to be set to 'B'[1]. A this setting the shutter remains open for as long as the release butto continues to be pressed. It is advisable to use a cable release to hol the shutter open without vibration.

Measuring with a built-in meter. Small format cameras with built-i meters usually have the measuring cell inside the camera behind th lens, or mounted on the camera body taking in the same angle view as the camera lens. Often the cell is intended to read the who subject area at once, but be careful here—if the subject has an ur equal distribution of light and dark areas the *largest* area will hav the greatest effect on the meter, irrespective of its importance. Th system works well enough when there are as many highlights a shadows, but in many instances in the studio it will be necessar to take the camera in close just to measure selected highlights an shadows accurately.

Most built-in meters are linked to the camera's shutter spee setting dial. First the ASA film speed is set on a dial and the shutt set to a speed (say 1/30 sec.). Looking through the viewfinder th photographer sees a superimposed moving needle—by opening o closing the lens aperture the needle can be moved to coincide with fixed mark, whereupon the lens is at the correct f number for th shutter speed chosen. If this coincidence cannot be carried out eve at widest aperture, the shutter has to be set to a slower speed (e. 1/15 or 1/8 sec.).

Measuring flash exposure. Ordinary exposure meters will n accurately measure the very brief pulse of light given by electron or bulb flash. When using flash as a light source we therefore us either a flash meter, or calculate on the basis of measuring the flas to-subject distance.

A flash meter, which looks like an enlarged conventional mete is set for the camera film speed and placed at the subject, facing th flash source. The flash is then fired, and a needle on the meter mov over a scale, stopping at the f number for correct exposure.

The shutter speed set on the camera is unimportant as long as th flash is of shorter duration than the shutter opening period (page 3: In practice we can just set the shutter to 1/30 sec., which is safe f both types of flash, and then concern ourselves only with f number

Unfortunately flash meters are more expensive than ordinal exposure meters. They also have disadvantages with *flashbulbs*,

Light-sensitive cell

24. Exposure meter for electronic flash.

[1] Stands for 'Brief' or (historically) 'Bulb', from the days when a pneumatic ball a air tube were used.

that a bulb must be used up just to make each measurement. The alternative is to measure the distance between flash (or if several, the *main* flash source) and the subject. Typically, this distance is set opposite film speed on a simple calculator dial on the flash unit, which then shows the f number required.

Special conditions affecting exposure measurement. Sometimes we have to give more exposure than our meter may indicate, irrespective of subject. This happens (1) When working very close up to the subject; and (2) When using a filter.

(1) As explained in Chapter 1, when we bring the camera closer to the subject the lens has to focus out further from the film. Inside the camera this is like being in a darkened room with a slide projector which is moved further from the screen—the image grows bigger but progressively *less bright*. This dimming is something that is not taken into account by f numbers, and so extra exposure time or wider aperture must be used in compensation. As shown on page 165, the increase only becomes significant when the subject is less than about six focal lengths from the lens.

Some lenses made for very close working (macro lenses) carry a special scale showing the exposure increases necessary at various focusing positions. Exposure meters built into cameras and measuring from behind the lens automatically take this increase into account.

(2) A coloured gelatine filter used over the camera lens darkens subject colours complementary to its own colour (plates 11 & 23). Used with panchromatic black & white film a yellow or red filter makes a pale blue sky appear darker and therefore emphasizes white clouds. Similarly green and red lines on artwork which would normally record as similar greys can be turned white and black respectively (green filter) or black and white (red filter). All these effects can be checked before shooting by first looking at the subject through the filter and observing the various tone values. Colour filters do not effectively alter the reproduction of colourless subjects on black & white film. It is therefore pointless to try to filter sky in totally overcast conditions.

Each colour filter works by absorbing some of the wavelengths in light entering the lens and must be compensated for by increased exposure. Film and filter manufacturers give suggested exposure multiplication factors.

Colourless grey 'neutral density' filters are occasionally useful just to dim the light coming through the lens. They are used to allow the prolonging of exposure time and so increase blur—in fact a deep

25. Method of making a series of test exposures on one piece of sheet film. Starting with the sheath fully removed 1 unit (e.g. 1 second) is given. The sheath is then returned, one quarter at a time, doubling the exposure given at each stage.

ANIMATE SUBJECTS
IN THE STUDIO

N.D. filter may allow an exposure time of several minutes to ⬛ given, making crowded streets and interiors of buildings record ⬛ if deserted. These filters also allow wide lens apertures to be used ⬛ give shallow depth of field, under brilliant lighting condition⬛ when even the fastest shutter speed would still give over-exposur⬛ N.D. filters are made with increase factors up to × 100.

Exposure tests. It is always useful to make an actual test exposu⬛ when working in the studio—not only to check exposure accurac⬛ but also lighting, colour tone rendering, and subject arrangemen⬛ Polaroid film (page 41) serves a valuable purpose here, or it may ⬛ possible to process a test on conventional film quickly. The latter h⬛ the advantage that it also takes into account the development co⬛ ditions to be given to the final result. If this test is to be on a she⬛ film try to make several strips of differing exposure on the sam⬛ sheet. When using normal contrast black & white films the⬛ 'bracketed' exposures should be in steps of at least double the e⬛ posure, owing to the latitude of such materials.

Photographing living, moving subjects introduces further co⬛ siderations to studio work. Backgrounds must be sufficientl⬛ generous in height and width to allow reasonable manoeuvring ⬛ subject and camera. For full length figure work rolls of 9 ft. wi⬛ background paper mounted on wall brackets at ceiling height a⬛ extremely useful. It is often helpful to use a lighting scheme whic⬛ is loose in the sense that the model should be free to move witho⬛ radical change occurring in lighting quality or quantity.

One must also consider the effect of the studio environment o⬛ the subject—uncomfortable heat and light coupled with the need t⬛ 'freeze' poses is likely to lead to a tense and contrived result. Henc⬛ the value of studio electronic flash which, with low wattage mode⬛ ling lamps in each head, allows the photographer to see exactly ho⬛ his lighting will appear without discomfort to the model. When th⬛ flash is fired the resulting 1/1000 sec. exposure freezes all subje⬛ movement; equally it allows the camera to be used in the hand with⬛ out any risk of image shake. (See plate 39.)

Much of the success or failure when photographing people in th⬛ studio rests in establishing a creative *rapport* between both partie⬛ so it is essential to simplify the mechanical aspect of photograph⬛ to the stage where one can fully concentrate on control of the sitte⬛ However experienced the model may be, he or she will requir⬛ direction—and this will not be forthcoming if the photographer ⬛ continually preoccupied with technical calculation. Check exposur⬛ only when radical changes of lighting position are made.

ate 21

asuring exposure for the sun
d sky alone reduces the tree
a silhouette and deliberately
tricts the total range of this
ture. The star-shaped
pearance of the sun was
sed by the shape of the lens
erture.

ate 22

ken on fast Royal X Pan film
full moonlight, giving one
ond exposure at the widest
s aperture, and followed up
th extra development.
dern battery exposure
ters can now measure under
se extremely low lighting
nditions. The use of a
0 mm. lens from a distant
wpoint has foreshortened
road and helped to
phasize its curves.

ate 23

Cathedral. Side lighting
phasizes detail, giving the
numental feeling and the
ndeur that exists at Ely.
chitectural photography has
be carefully planned in terms
lighting conditions and time
day. A yellow filter was
d to darken reproduction
the blue sky.

ate 24

tails of the tracery of the
f, Ely Cathedral. Extreme
hting contrast is always the
blem in this type of shot;
ficient exposure must be
en for detail to record in the
ings but often windows
uire local exposure when
nting to avoid a 'burnt out'
ect.

Plate 25

Portrait of the millionaire
inventor of 'cats' eyes' road
studs. The simplicity of the
chair and background helps
towards creating an interesting
image of an unusual character.

Plate 26

A straightforward photograph
in which the snow covered
ground gives strong tonal
emphasis to the figure in the
foreground.

Plate 27

This woman walking with her
children was photographed at
1/30th of a second, panning the
camera in the direction the
woman was walking to give
separation and liveliness to an
otherwise boring picture.
(See figure 26.)

Plate 28

Street scene. The exposure for
this photograph was calculated
from the group in the rear so
that the strong highlights and
deep shadows of the foreground
and distance have lost detail.
The use of the shapes of the
man and the dog give a strong
feeling of the environment.

Plate 29

The Humanist Society,
photographed in the studio
using a 6′ × 4′ flash 'window
light'. This was taken for
newspaper reproduction and
soft lighting was chosen so that
every face would reproduce
clearly.

Plate 30

The girl in this photograph was
harshly illuminated but printed
light on soft paper to
emphasize the luminosity
needed for this shot.

Plate 31

The hands of Henry Moore,
emphasizing the growth of his
finger joints caused by the
constant handling of sculpting
tools over many years.
Photographed in daylight on
Tri X film.

Plate 32

A figure study in a darkened
room. The model was
illuminated with soft diffused
floodlighting to emphasize
shape and softness, without
giving too much emphasis to
the form.

Plate 33

Nude. Soft directional lighting
and shallow depth of field were
used to emphasize form rather
than texture. The background
was lit at greater intensity so
that no tones recorded.

Plate 34

In this portrait the lighting
consisted of a 1,000 watt
spotlight on the background,
the remainder being reflected
from white walls and ceiling
behind the camera.

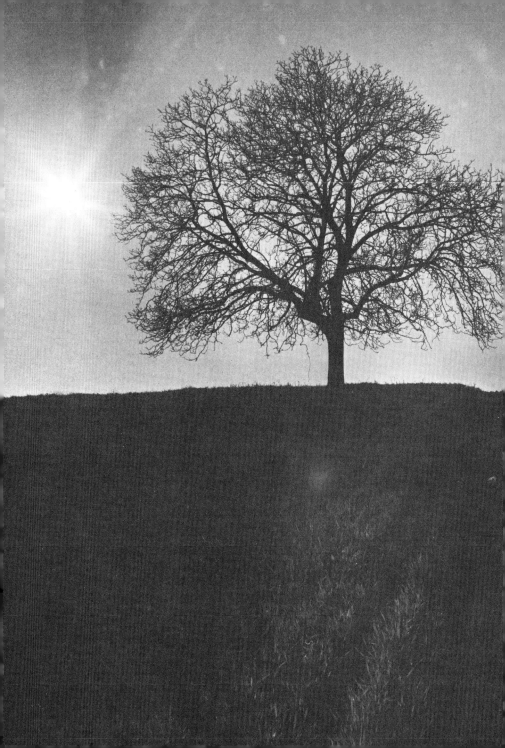

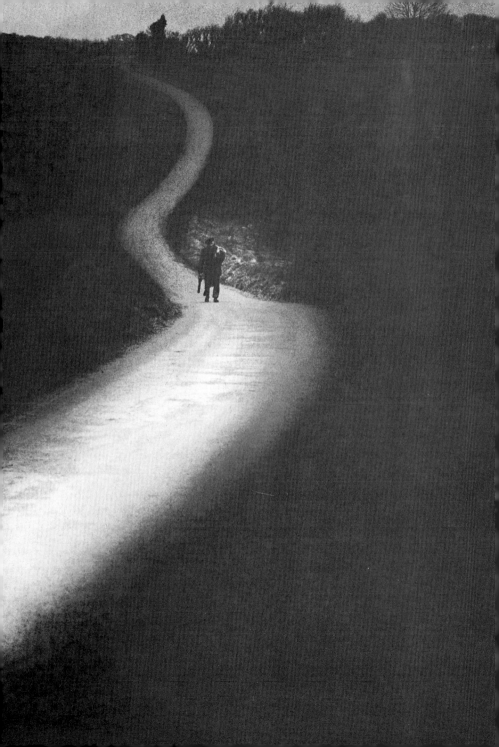

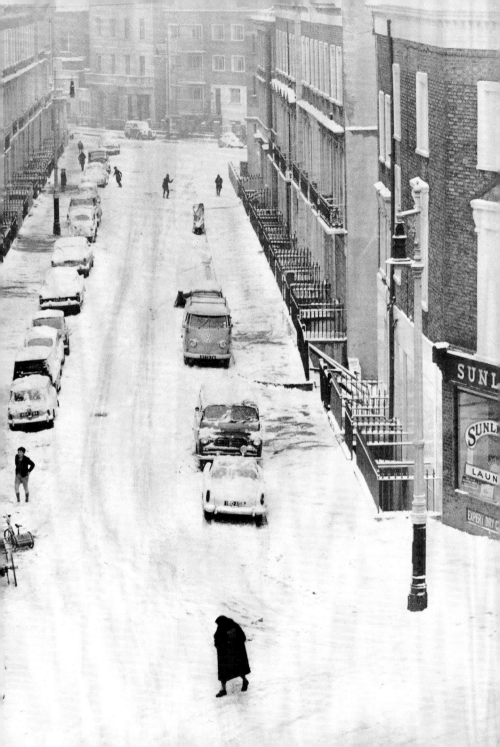

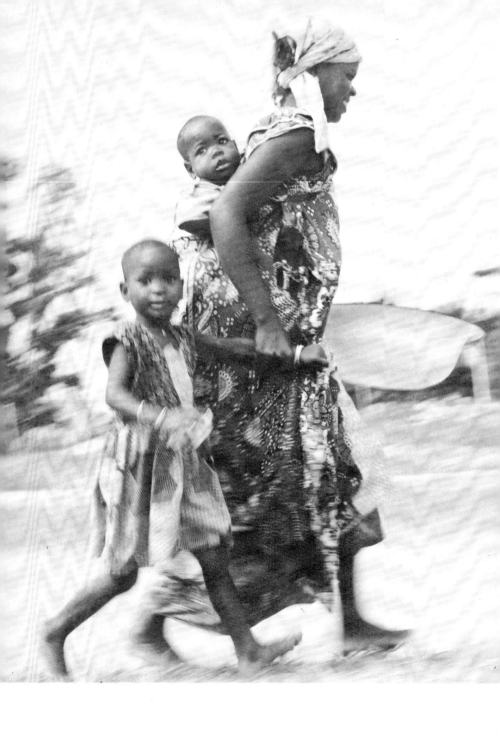

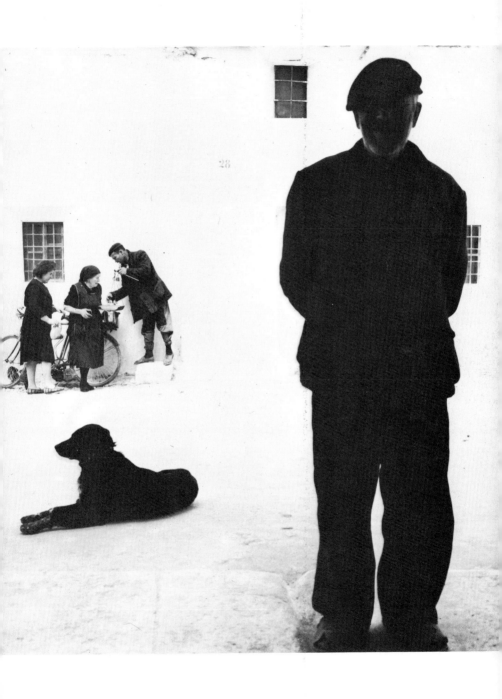

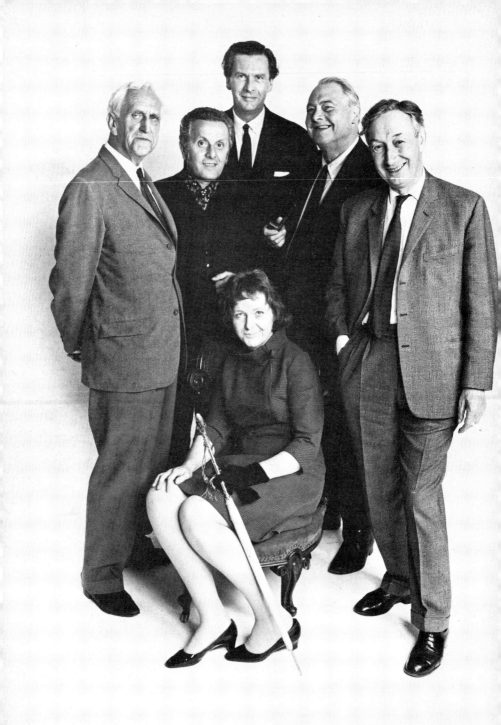

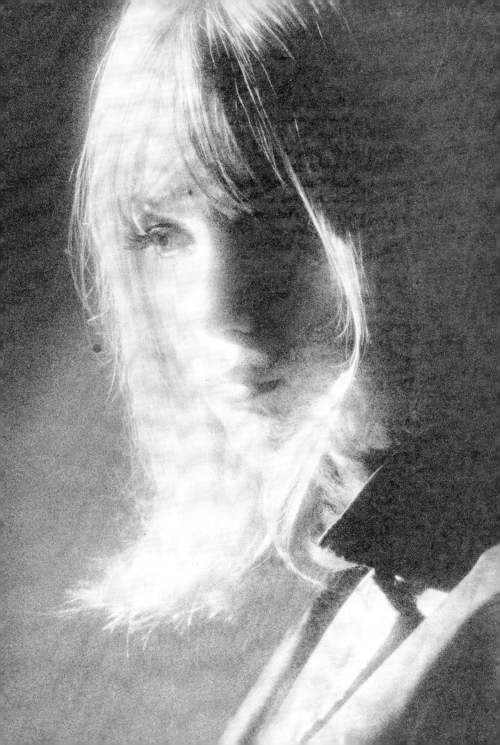

(overleaf)

Flash is not, however, the panacea for all animate subjects. Its freezing of movement becomes a limitation when some blur is desirable, and it is here that studio tungsten lamps and longer shutter durations again become useful. Experiments at different shutter settings are always needed because the exact speed of a moving subject can seldom be gauged. A rapidly moving dancer might be exposed at between 1/30 and 1/4 sec. (take an ordinary exposure meter reading and use the f numbers shown opposite these speeds). Where possible use underlit backgrounds so that detail does not record strongly through the blur.

As a further refinement a flash can also be linked to the camera. The flash goes off when the slow speed shutter first opens—giving a frozen image to which is added blur from the tungsten lit subject during the rest of the time (e.g. $\frac{1}{4}$ sec.) the shutter remains open. (The flash must be a suitable distance from the subject for the aperture in use.)

Mention should be made here of a further method of recording movement, by photographing through a rapidly spinning cardboard disc on a power drill. The disc has a cut out segment, acting as a fast repeating shutter. The moving subject records as multiple, sharp, overlapping images.

SHOOTING ON LOCATION

The advantage of working in the studio is that everything can be under our control. On location, however, we have to face elements which, to a greater or lesser extent, often control us. These imponderables include the quality and quantity of existing lighting; the difficulties of imaging and meter reading fast moving or other unapproachable subjects; also the real or imagined embarrassments of actually working in public.

Lighting. Existing lighting is often found to be (1) from the wrong direction (2) too hard, or too diffuse, or uneven (3) too dim.

Immovable subjects such as landscapes and architecture may only receive sunlight from an appropriate direction at one time of the day —and only at certain periods of the year. Architectural photography therefore calls for thoroughly pre-planned shooting, according to compass and weather forecast. Different facets of a building may have to be shot at different times of day, making best use of sunlight or diffuse cloudy conditions to enhance form and texture (as spots or floods are used in the studio). North facing structures may of necessity have to be shot during an overcast day or, if lit from within, at dusk. Plates 3 and 23 illustrate these points.

35
f a photo-
alistic sequence on
rsing profession.
ngle, composition,
ssion, and harsh
nation from a
g light all contribute
sense of urgency.

More mobile subjects can usually be moved around until an a[?] offering suitable lighting quality is found. For soft lighting put t[?] subject in an area of shadow, if necessary adding some directio[?] lighting from a reflector board or other bright surface placed in t[?] sunlight.

When shooting indoors one can often bounce light off a surf[?] behind the camera (e.g. walls or ceiling) to help make extremely c[?] trasty illumination streaming in through windows more even. ([?] plate 41.) In locations such as pubs, markets, and railway statio[?] there may be insufficient good light—and it is often impractical[?] use auxiliary lighting because this may make the taking of pictu[?] too conspicuous; or the subject may be too large to be effectiv[?] lit this way. The only solution then may be to use whatever lighti[?] exists, making the most of it with the widest aperture lens, t[?] slowest shutter speeds that can be safely used, and the fastest fil[?]

Shooting with the lens wide open calls for very accurate focusi[?] as depth of field will be minimal. Try to avoid the need to shar[?] record subjects all at differing distances in the same picture.[?] course shutter speeds longer than about 1/30 sec. really call fo[?] tripod if camera shake is to be avoided. But if a tripod is impracti[?] try resting the camera on a convenient fixed object, or pressing[?] against a wall or pillar. Most films can have their box speed 'push[?] still further (typically × 2) by giving extra development, but t[?] results in more noticeable grain and also increases image contrast.[?]

Exposure calculation. Exposure meters are not easy to use under ve[?] dim lighting conditions such as those mentioned above, or for nig[?] scenes. The newest types of meter which use built-in miniatu[?] batteries will often give readings where older meters will n[?] Alternatively a meter which will not read from the subject itself m[?] just show some response when made to read from a clean white ca[?] under the same lighting. Give about eight times the exposure th[?] indicated for subjects such as people under these lighting c[?] ditions.

Under more favourable lighting conditions always try to ma[?] highlight and shadow readings, as suggested for the studio. Howev[?] sometimes approaching the subject closely enough to make lo[?] meter readings becomes impractical—when shooting across wa[?] for example, or from the touch-line at football matches. We th[?] have to find a suitable local substitute (taking a reading from t[?] back of our hand instead of a distant face, or local grass instead[?] distant fields.) Obviously both substitute and subject must[?] receiving identical illumination.

Imaging fast moving subjects. Fast moving vehicles, people and animals running are difficult to sight within the viewfinder, particularly if they are moving at right angles to the line of view. Their speed, too, can defy even the fastest shutter speed to freeze movement.

Often it is easier to 'pan' the camera in the direction of movement, accelerating the camera whilst the subject is still some way off, so that it becomes relatively stationary in the viewfinder as it flashes

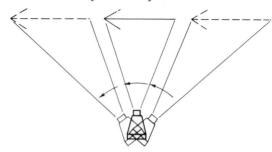

Panning a moving ect. Start swinging amera while the ect is still some way accelerating until are moving at about ame speed, and nuing on the swing making the sure.

past the photographer. With practice it is possible to fire the shutter at this critical moment and record subject detail even at shutter settings of 1/125 or 1/60. At the same time stationary objects in the background record as extremely blurred giving a 'performer's impression' of the action, whereas a stationary camera gives a blurred performer and sharp background, or 'spectator's eye view'.

One interesting aspect of panning is that only those parts of the subject image all moving at the same speed and direction record equally sharply. For example, some of the spokes in a rotating motor cycle wheel still blur where their direction differs from that of the bike as a whole. See also plate 27.

Handling people. All photographers are self-conscious when first using a camera to photograph strangers in public places—it feels as if one is infringing other people's privacy. In practice many of these conscript models are too preoccupied to notice the camera, whilst of those who do some are flattered and others too self-conscious to make themselves conspicuous by complaining.

To make any headway even the most reticent photographer must develop an extrovert approach—unflinchingly pushing the camera up to people's faces, wangling his way into their offices—even holding up traffic by lying in the road if this will help to make an effective picture.

Long-focus lenses provide some defence by allowing us to retreat into doorways and shoot head-and-shoulders pictures safely from across the street. Unfortunately the flattened perspective this pro-

duces soon becomes boring—the images lack the immediacy and punch of a genuinely close viewpoint, shot perhaps with a wide angle lens, or normal lens with close-up attachment (plate 42).

At the same time there are methods of obscuring one's intention such as shooting via a mirror or using a waist level camera at 90° the direction of the body. Camera adjusting time can be saved by making exposure readings from substitute subjects as describe earlier, and by focusing on something judged to be the same distance away as the subject but in another direction. Alternatively distance can be guessed and set on the lens focusing scale. Having made the surreptitious settings we can swing the camera around quickly and fire the shutter before anyone is aware of what is going on.

Although some people may support the principle of complete naturalistic photography, in practice it is usually possible to give greater significance to a picture by some reorganization of its component elements. After covering oneself by shooting a situation 'as it stands' always try variations with slight adjustments to viewpoint figures, background and foreground content, expression, etc.

Finally a word of warning. Not only is it courtesy to obtain permission before taking photographs on people's premises—it is sometimes a legal necessity, and an unlucky photographer can be summoned for a variety of offences ranging from trespass to industrial espionage. Check the position before shooting in areas such as railway stations, graveyards, cinemas and theatres, government establishments, industrial plants, art galleries and museums.

Some of the more enlightened museums such as the Victoria and Albert in London allow photographs to be taken without formal permission, provided that facilities such as special lighting are not required. As a carry-over from the days of itinerant 'walkie' photographers, pictures cannot be taken in the Royal Parks using a camera *on a tripod* unless a permit is previously obtained.

Legally the photographer cannot be prosecuted for photographing strangers unless he thereby causes obstruction or a breach of the peace, or later uses the pictures in a way which the person proves derogatory to him or her. This is one reason why a professional photographer hiring a model for a session ensures that he or she signs a 'model release form', giving the photographer legal right to use the shots in return for the fee.

SUBJECTS HANDLED
BY THE DESIGNER
USING RECORD
PHOTOGRAPHY

Copying flat artwork and paintings. Usually a tripod mounted large format camera is desirable as a choice of black & white films in various contrasts and colour sensitivities is then available, and negatives can be individually processed as the subject-matter dictates. Setting

up involves a more-or-less formal procedure—secure the original to a wall or horizontal surface but avoid using pins or pegs which cast shadows over wanted areas. The camera must be very carefully centred to the original, which should be surrounded by black paper or other flare-reducing material. Use a lens-hood to protect the lens from stray light.

Lighting must be even, and preferably diffuse. Two floodlights,

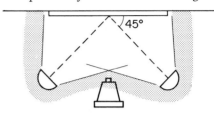

27. Plan view of lighting arrangements for evenly illuminating a two-dimensional painting.

strip tubes or diffused flash heads, each about 45° to the surface of the original, can be used. They must be sufficiently distant not to illuminate the edges more than the centre. Diffuse daylight may be suitable in character but may have to be evened up with white reflector boards. Take the greatest care to check for reflections and glare spots from the subject. When recording paintings behind glass *in situ* it is usually necessary to block the reflections of nearby bright objects by means of black cloths or screens.

Multicoloured originals having a range of tones (colour photographs, paintings, watercolours) photograph well on normal contrast panchromatic film such as Plus X or HP4. Use the exposure meter in the same way as if shooting a still life—averaging the readings from dark and light detail areas. Remember to allow extra exposure for close-up working (Appendix II). Often the use of a pale yellow filter (daylight) or pale green (artificial light) helps to counteract the over-light reproduction of blues, and shifts the tone reproduction of colours closer to the brightnesses experienced by the eye.

Although flat copy work involves no depth of field problems, stopping down the lens to f16 or f22 helps ensure sharpness right out to the corners of the image. Drawings and sketches in pencil can be shot on blue-sensitive normal contrast film such as Ilford N5 31. This can be loaded and processed under orange (printing room) safelighting. Final judgement of exposure and processing have to be based on trial and error, remembering that development increases contrast, exposure increases shadow detail. The main aim is to maintain good tone separation within the drawing without exaggerating contrast to the point where paper reproduces stark white and pencilled shadows a detailless black. Faded warm coloured images such

as old sepia photographs copy excellently on blue-sensitive film often reverting to their original appearance.

Line artwork such as drawings in indian ink, printed text, or coarse screened photographs in newspapers copy well on line film. The originals here only contain black & white, which is well preserved on film such as Ilford N5.50 processed in line developer. The film should also be panchromatic (e.g. R5.50) if colours are present, as in maps, posters on coloured paper, etc., but remember that such film must be processed in darkness.

To use the meter for line work, take a reading from a white card placed over the artwork and give 4–6 times the indicated exposure. Evenly distributed lighting and correct exposure are more critical with line film than for any other black & white material, and a test exposure is usually necessary. If a series of bracketed exposures given make the differences between exposures *less* than for normal contrast film (say multiples of $\times 1\frac{1}{2}$).

Constructed models. The three-dimensional models produced by industrial and interior designers, town planners and architects require some thought in terms of scale and lighting. Usually it is desirable for the photograph to simulate the appearance of the structure when constructed full size. If this is to be a 'standing man's eye view' the centre of the camera lens should be at a height above 'ground' level equal to average eye height (say 5′ 3″) times the scale of the model, e.g. in the case of a 1 : 50 scale, $1\frac{1}{4}''$ high.

Similarly if we want to show the appearances of the final structure as from a viewpoint 50 ft. away across the street, the camera lens should be at this distance times the scale of the model. Where possible keep to a normal angle lens, although it may be necessary to change to a wide angle if inclusion of more subject-matter is essential.

28. Using a 45° mirror to give a camera viewpoint actually within an architectural model.

Often when photographing interior design models the required viewpoint is found to be from some position within the structure quite inaccessible for the camera. A 45° mirror can be helpful here (figure 28). The mirror should preferably be front silvered to avoid double reflections. Dentists' mirrors are ideal. Special lens equipment is also available for this work.[1]

Lighting should simulate final natural conditions as closely as possible. Don't therefore create two 'suns' by using two direct light sources. Make one predominant lamp cast shadows of realistic length and obey the points of the compass if marked on an architectural model—the sun in England doesn't shine from the north.

[1] Optec Reactors Ltd., London.

Light sources in building interiors are often important elements in their design and should be simulated as closely as possible. It is sometimes effective to use several small (torch) lamps, or reflect light from carefully placed small mirrors. Alternatively bounce light from a white paper canopy over the set to give soft overall illumination as if from ceiling strip tubes or an overcast sky.

Backgrounds are often a problem with big models, particularly when they have to be shot in offices or at exhibitions. Sometimes it is possible to so under-light background areas that detail is lost. Another useful technique is to stop down well so that an exposure time of several seconds is needed. During the whole of this period a sheet of paper or cloth is held up behind the model and gently kept on the move. Creases and other blemishes disappear in blur, and the background records even and clean.

When recording silverware and jewellery, reflected light from a large white canopy or even a 'tent' surrounding the subject helps to reduce reflected detail of the studio surroundings and intense highlights. Taken to excess, however, it has a deadly flattening effect, losing entirely the inherent reflective quality of the material. (Further suggestions on handling the colour photography of stained glass, paintings, and three dimensional objects appear on pages 148 ff.)

te 36
: diffused foggy effect
his picture and in
ce 52 was achieved by
netting with
slucent plastic
ing exposure when
oting. The rest is
e in the printing by
ging the exposed
er and applying
eloper locally on
ton wool swabs to
ieve an uneven
on.

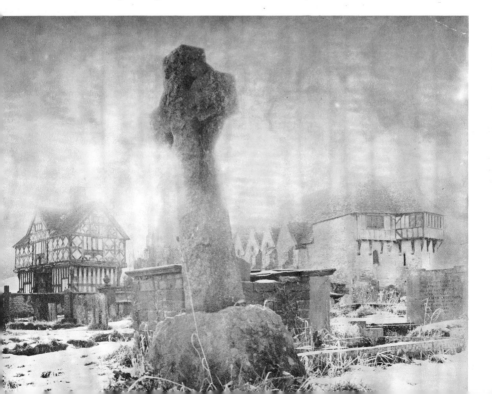

CHAPTER 5 Black & White Processing

New developments such as Polaroid film and high-speed processing machinery will eventually allow us to see results almost as rapidly as a TV programme can be replayed from videotape. But at the moment these methods are still limited and remain expensive for the average photographer; for most of his work he must be prepared to carry out the twenty minute or so conventional process cycle before seeing his negatives.

Exposed film from the camera need not be processed immediately and can be left for some days or even weeks without deteriorating. Much depends upon storage conditions—keep the wrapped film away from strong light, heat, damp and gases such as coke fumes. (Wrapped in foil and stored in the main part of a domestic refrigerator exposed film can be kept safely for months.)

PROCESSING ROOM
REQUIREMENTS

Film processing calls for the action of chemicals on the film emulsion. The most common method of doing this is to put the film into a series of solutions containing dissolved chemicals, one for each separate stage of processing. We therefore need a processing tank, preferably with a light-tight lid so that we do not have to remain in the dark during the whole time the film is being developed.

If we are only processing occasional roll and 35 mm. film it

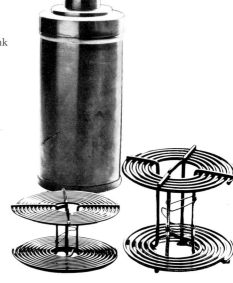

29. Stainless steel daylight developing tank (treble-decker) and spirals for (left) 35 mm. and (right) roll film.

possible to manage with just one daylight developing tank, plus bottles for solutions, a thermometer, a clock, running water for washing, and pegs to hang up the film for drying. Conditions under which the tank can be loaded with the film in total darkness are essential, but even here a dust free sleeping bag, the space between sheets of a made bed, a photographic changing bag, or just a dark cupboard can be used. We can thereafter manage with simple domestic bathroom facilities.

If regular processing is being undertaken, including sheet film as well as roll film, a room specially devoted to this work will make life far easier. The room can be quite small (about 2 metres square for one worker), light-tight yet ventilated, and equipped with hot and cold running water and drainage, ceiling lights and a power point. Consciously divide the room into 'dry' and 'wet' areas. The dry part can be a shelf or bench on which exposed film may be handled in the dark—loaded into tanks for example—without being contaminated with splashed solutions.

The wet area is a flat bottomed sink about 20 cms. deep which can be part-filled with water at an appropriate temperature (usually 20°C) and so act as a water jacket in which tanks can stand during processing. The most convenient way of constructing this sink is to make it from wood, covered with chemical-proof sheet PVC (see page 168). Try to maintain some form of gentle air heating in the room so that the water jacket does not lose temperature rapidly; alternatively use a thermostatically controlled immersion heater.

TABLE 4 Minimum photographic hardware

For Black & White Negative Processing	For Black & White Printing
Developing tank, and film spiral or (sheet film) hanger	Enlarger
Thermometer	Easel or pins or weights to hold down paper
Clock or timer	Three dishes; developer, fixer and rinse/wash
Two bottles, one for developer and one for fixer	Thermometer
Film clips or pegs	Clock (seconds and minutes)
Drying line (or cabinet)	Safelight
	Dryer/glazer or drying line and clips

The smallest processing tanks accommodate one roll of 35 mm film wound into a plastic or metal spiral. The larger tanks take double or treble decker spirals. Most of these tanks have a light trapped funnel in their lids, so that, once loaded, the various solutions can be poured in or out in turn under ordinary room lighting without having to re-open the tank.

Tanks for sheet films are rectangular, holding 16 litres ($3\frac{1}{2}$ gallon) of solution. The sheets are suspended in the tank on stainless steel hangers and although the lids are light-tight it is usual to transfer the film from tank to tank in the dark rather than pour large volumes of solution in and out of one tank. Racks are available to take up to a dozen or so roll-film spirals, so that the owner of 16 litre tanks can use them for his small format work as well.

Preparing solutions. Conventional black & white negative processing calls for the following sequence of solutions: (1) Developer, (2) Water rinse, (3) Fixer (acid hypo), (4) Water wash. Typical developers for general purpose black & white negatives include Kodak D76, D61 and Ilford ID67. All the developers are bought as tins of pre-weighed powder to make up a particular volume of working solution e.g. 500 ccs., 1 litre, 16 litres. Some are also available in concentrated liquid form. Follow the mixing instructions carefully, and leave freshly mixed developer in a storage bottle (or 16 litre tank) for at least an hour before use, to allow time for further dissolving of contents and lowering of temperature.

The fixer can also be bought in tins of powder, dissolved and stored in a similar manner. Fixing solution can be corrosive over a period of time and should not be allowed to soak into woodwork, plaster, and concrete. Under normal conditions of working acid hypo is harmless to the hands, although the slight acid content will make any open cut sting unpleasantly.

Developer can stain the fingers if they are constantly in the solution, and for a very small minority of people it can cause skin inflammations. Always rinse the hands after they have been in processing solutions and never contaminate developer with fixer or vice versa. Incidentally, don't be tempted to improvise mixing containers, dishes, tanks, etc., for photography from handy household items. If materials such as tin, tin solder, bronze, iron, silver, copper and zinc are brought into contact with photographic solutions they become corroded and stained themselves, and may contaminate and destroy the properties of the solution. Glass, plastics, polythene, stainless steel, enamelled steel, glazed porcelain, and smooth fibre glass are all harmless.

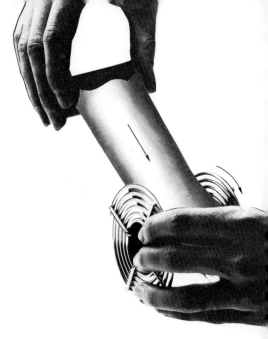

30. Loading a roll film
into a developing spiral.

Handling the film. Each 35 mm. and roll-film must first be loaded into a plastic or stainless steel spiral. Some types have top and bottom flanges which are adjustable for different sized films. Each flange has a moulded spiral groove. The film is gently fed into the grooves so that it takes on a coil form—each part of the coil sufficiently separated from adjacent coils for the solutions to be able to circulate evenly throughout the film. The loaded spiral therefore forms a compact unit to handle instead of several feet of awkward, delicate film.

Spiral loading is the only aspect of negative processing requiring manipulative skill because it must take place in the dark. Practise first in the light, using an old film. When loading 35 mm. film trim the shaped film leader to a clean right-angle, then having switched out the light pull off one end of the cassette, remove the spool and feed the film from it into the spiral.

When processing roll-film break the seal and unroll a few inches of backing paper in the dark until the end of the film is found. The film is then loaded into the spiral until the far end is reached, taped to the backing paper. Detach film from paper but take care not to kink the film as this will form crescent shaped marks on the negatives. (Read the instructions with the developing tank—some spirals are designed to be loaded from the centre outwards.) The spirals can

now go into their (empty) tanks, the lids secured and the room ligh
switched on again.

Sheet films must be removed from the camera slides in the da
and each attached at all four corners to a film hanger. The hange
are then lowered into the large tank of developer, the tank lid r
placed and lights switched on.

Processing Sequence

a) *Pre-soaking.* This is an optional stage for roll and 35 mm. films
small tanks. By filling the tanks with water (at a temperature matc
ing the developer) and agitating the film for about 30 seconds tl
gelatine of the film is evenly swollen and air bells dispelled, so th
at the next stage developer has a better chance of even action. Tl
water is then poured from the tank.

31. Exposure and processing of a roll film, using a developing tank. Rather than work in total darkness a light-tight lid is used on the tank.

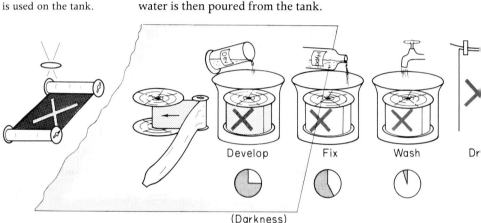

b) *Developing.* The developer has been waiting at the recommend
temperature (usually 20°C) and is now either poured from a beak
into a 35 mm. roll-film tank, or waits ready in a 16 litre tank
receive sheet films or spirals. In the developer the parts of the emi
sion which received light are darkened into visible black silver. It
therefore essential that the developer acts evenly.

The amount of development must be strictly controlled. Time
development depends upon solution temperature and type of fil
(the developer manufacturers quote recommendations), also the a;
of the developer and the amount of agitation given. Frequent agit
tion of the film is important in order to keep bringing fresh develop
into contact with the emulsion. Agitation typically takes place f
5 seconds every minute—raising and lowering sheet film hange
and spirals in the big tank (in darkness) or inverting the small ro
film tank. The most important period of agitation is at the very begi

ing of development, especially when pre-soaking has not been given. Insufficient agitation results in patchiness and 'streamers' of uneven density from image highlight areas. These faults cannot be corrected afterwards.

At the moment the development time has expired pour the developer back into the storage bottle (small tanks) or transfer the film hangers in the dark from the developing tank to the rinse tank.

c) *Rinsing*. The developer is basically alkaline; the fixer is acid. Therefore any carry-over of developer into the fixer contaminates and weakens the latter, slowing fixer action on the film and risking stains. A water rinse is desirable for a period of about 10 seconds, with plenty of agitation. The roll-film tank can just be filled with water and emptied again.

d) *Fixing*. In the fixer those parts of the silver emulsion unaffected by development (i.e. subject blacks) are made transparent and soluble —removable completely in the final wash. If a film is not evenly or fully fixed it will slowly form purplish patches and grow opaque, perhaps months later.

Full fixing takes about 8–10 minutes (longer if the solution has been much used) but after about 1 minute the film is no longer vulnerable to light and may be taken out briefly and examined in white light for the first time. Fixer temperature should be within about 3°C of the developer and the film should continue to have occasional agitation, particularly during its first minute in the solution. If necessary the film can stay in the fixer for longer than the required fixing time, but excessive time (say beyond an hour) may cause some bleaching of the black image.

e) *Washing*. The purpose of washing is to remove all the (invisible) salts from the film which would otherwise dry out on its surface, or in time cause the image to bleach or turn sepia. Ensure a good stream of running water over the film surface for about 30 minutes, or alternatively fill and empty the tank about a dozen times during a similar period.

The difference between good and ineffective washing cannot be seen at the time, but the photographer must discipline himself to do this job properly if his results are to last. A few drops of wetting agent can be added to the final wash—as a mild detergent this assists even drying.

f) *Drying*. 35 mm. and roll-films are now removed from spirals, and pegs

or stainless steel clips are attached at each end. Together with she films on their hangers they are suspended on rods or wire in a clea *dust-free area*. This may be a purpose-built drying cabinet wi built-in fan heater which dries the film in about 15 minutes, or bathroom which can be left overnight.

A great deal of irretrievable damage can occur at this stage fro dust and grit settling from the air, or from films dropping on the flo or touching each other when half dry. Only when the film is con pletely dry cut up the negatives into strips and immediately prote them in transparent envelope sleeves. (The suppliers of these ar other equipment chemicals and materials are listed in Appendix I\

TABLE 5 Processing a black & white roll-film—typical time sequence

Time (minutes)	Stage	Solution	Notes
1	Pre-soak (optional)	Water	Preferably with a drop wetting agent added
10	Develop	Proprietary brand of negative developer	Time quoted is typical b will depend upon type film, temperature and ag See instructions with developer
1	Rinse	Water	
1 ⎫ 9 ⎭	Fix	Acid hypo	After about 1 minute th film can be examined in white light
20	Wash	Water	
1	Wetting agent		Wetting agent added to final rinse
15	Dry		In drying cabinet (or about 2 hours if dried in ordinary room condition

—

58 minutes

Assessing negatives. The fact that all subject tones are reversed mak a negative rather difficult to assess, particularly subtleties such as

model's expression. Some technical aspects such as sharpness, exposure, and development can, however, be checked at once (a table of faults and their probable causes appears in Appendix III). In general we should aim for a negative which looks slightly less contrasty than a good print or transparency, and contains all the shadow detail deemed important. When in doubt, over-expose.

If the subject lighting has been too contrasty for the film, shadows will appear empty and highlights dense, even with normal development. More exposure improves shadow detail but makes highlights even denser. If the subject cannot be re-lit give about twice the 'correct' exposure and reduce development to about two thirds normal time.

WHICH DEVELOPER? So far we have discussed the use of general purpose negative developers—as used for normal contrast film, giving moderate grain, and having good keeping properties of several weeks. Other useful developers include 'fine grain' and 'line' types.

Fine Grain Developers. The terms 'grain' or 'graininess' refer to the granular appearance of the black silver photographic image when enlarged (plate 1). As stated in Chapter 3, grain quality is mostly inherent in the film used, being coarsest with very fast materials. However, many proprietary brands of fine grain developers exist (e.g. 'Promicol', 'Microdol X') which by their gentle action minimize the clumping together of grains and make the most of a film's fine grain properties. These developers tend to be rather slower in their action than general purpose types; being less powerful some also require the film to be given slightly more exposure, i.e. given a lower speed rating.

High Contrast 'Line' Developers. Line developers (Kodak D8, Ilford ID 13) are intended to give images consisting only of dense black and clear areas on line sheet film. They are used mostly in the copying of line artwork. Line developers are very alkaline indeed and the chemicals are normally made up and stored as two separate solutions, 'A' and 'B'. Equal parts of each are then mixed just before development begins, as the mixed developer discolours and loses its strength within 10 minutes or so. The sheet film is therefore processed in a dish rather than a tank. 'Lith' developers for lithographic materials such as 'Kodalith' have similar characteristics, and give excellent extreme contrast results.

Machine Processing. In view of the rather dull routine of processing,

coupled with the importance of consistency, this aspect of photography is ideally handled by machine. For many years machines have existed for the processing of films in *large quantities,* as used for developing films handed in to chemists shops. Such equipment costs tens of thousands of pounds. The idea of an inexpensive but reliable automatic machine for the smaller user has only just begun to attract the interest of designers, but in time cheap equipment this type will be in general use. Research also continues into methods of processing without using liquids at all—either by applying heat or using jellied chemicals as used on Polaroid films (page 41).

AFTER-TREATMENT OF THE NEGATIVE

Sometimes viewing the negative is something of a shock—it is too dark or too light, and yet the subject cannot be reshot. Can anything now be done to lighten or darken the image? Intensifying and reducing chemicals are marketed for these desperate cases, but will never quite transform the image into what would have been the result of correct exposure and development.

Reduction. The most widely used reducer contains potassium ferri-cyanide and hypo, and is known as 'Farmers Reducer'. It is marketed in small packs of powder. The dense negative is placed in a solution of this reducer and transferred between it and water (which stops the action) until negative density is judged to be correct. Unfortunately the reducer tends to affect the subject shadow areas more than highlights. It may therefore increase contrast and is most effective for over-exposed, under-developed negatives. The reducer also increases the visual appearance of the grain.

Intensification. Various intensifiers are available. Perhaps the most useful type contains potassium bichromate and is known as 'Chromium Intensifier'. The negative is left in the solution until largely bleached, and then rinsed and placed in a strong, general purpose developer. This produces more density than was originally present, but beware—the solution is an *intensifier* and can only darken detail already present on the negative. It cannot build up on shadow detail which does not exist owing to under-exposure.

Intensification is more useful for correcting underdeveloped than under-exposed negatives. Most intensifiers also increase graininess. Negatives for both intensification and reduction should first be thoroughly fixed and washed. Failure to do this will create stains and unevenness.

Printing Black & White Negatives

Printing photographic negatives mainly differs from printing via silk screen or lithography, in that *light* is used instead of ink. Negatives are printed by contact or projection. For contact printing the negative is placed in physical contact with light-sensitive paper and light directed through the negative. Alternatively the negative is set up in an enlarger (not unlike a vertically mounted slide projector) and an enlarged image sharply projected down onto the paper. In both instances the exposed paper then requires a sequence of developing, fixing, and washing similar to negative processing.

Image shape, density, and contrast can all be manipulated at the printing stage, allowing some creative control. However, although bad printing can greatly mar good camera work, bad camera work can very rarely be compensated by even the most skilled printing.

PRINTING ROOM REQUIREMENTS
Whereas a cupboard, a bathroom, and a daylight developing tank will just about serve the needs of simple film processing, printing deserves better facilities. For one thing more space is required for equipment, and we are likely to spend more time on this job than on processing negatives.

A ventilated but light-tight room about 2×3 metres with ample ceiling height is about the minimum for one person printing. Once again the room should be strictly divided into wet and dry areas. The dry bench must be wide enough to support the enlarger and allow space for handling negatives and paper; the shallow sink long enough to contain at least three dishes of maximum print size. Washing and drying can take place in another room.

Hot and cold mixer tap water supplies, drainage, and a power-point (this time for the enlarger) are again required, plus one or two safelights. The most commonly used paper—bromide paper—is insensitive to orange light, and can be handled openly under lamps screened with filters of this colour. The most important position for a safelight is over the processing sink, but check the maker's instructions in terms of the minimum safe distance from light-sensitive materials.

We also require cupboards under the dry bench for storing boxes of paper; a sheet of thin plate glass about 20×30 cms. for contact printing; and an easily seen electric clock to time seconds and minutes. On the wet bench side bottles of developer, a dish thermometer and measuring beaker can be stored on a shelf. Three trans-

parent or white plastic dishes are needed—for print developer, wat rinse, and fixer respectively. Choose developer and rinse dishes suit the size of print currently being made. Table 6 shows standa sizes.

To maintain the developer at the required temperature (usua 20°C) it may be helpful to stand the developing dish in a larger di containing some water at this temperature. Fit a hose from the mix tap to the rinse dish and allow a gentle current of water to run fro it and overflow down the sink. The fixer dish should be as large possible, to allow plenty of room for a compilation of prints. A lar dish or tank is also needed for final washing. This may easily ta place under a good supply of running water in another room.

Preparing solutions. Developers used for printing materials (e Kodak D163, Ilford P-Q Universal) are similar to but rather m active than general purpose negative developers. Developer bought either as concentrated liquid simply requiring dilution, made up into stock solution from tinned powder. At normal wor ing strength most manufacturers recommend a developing time o minutes at 20°C. Use a generous quantity of developer in the dish the cost of paper normally exceeds that of developer, so that unev action and staining due to insufficient solution becomes fa economy.

Acid fixers for printing are very similar in content to those f films, and can be made up from tinned powder or weighed out hy crystals, with the addition of liquid acid hardener. One litre of wor ing strength fixer is sufficient for approximately thirty $10'' \times$ paper prints.

The enlarger. Enlargers all differ in detail but, as figure 33 shows, consists basically of a lamphouse and optical system to evenly re illuminate the negative, a lens to image this negative onto the ba board, a method of focusing the lens, and a means of raising t whole enlarger head up to varying height above the baseboard.

For making contact prints the enlarger is simply used to proj an even patch of light onto the baseboard. The sheet of paper, cover by the negative(s) and a sheet of glass, is laid on the baseboard and t enlarger light then switched on to give the exposure. When used f enlarging, the negative is inserted in the negative carrier—eith sandwiched between open metal frames or sheets of thin glass. T lamp is now switched on, and the lens aperture opened wide so th the projected image of the negative may easily be focused onto t baseboard. If the image is too small the whole enlarger head is raise

if too large the head is lowered. In either case refocusing will be necessary. The lens is finally stopped down, making the enlarger ready for printing.

When deciding on an enlarger bear in mind the following:

1. The most important part of an enlarger is its lens. There is little point in having a good camera lens if the negatives it produces then all go through an enlarger lens which turns out muddy, unsharp enlargements. Once again we should buy the best we can afford.

A good enlarging lens is made for the job, having a focal length approximately equal to the diagonal of the negative it is designed to enlarge (e.g. 60 mm. for 35 mm.; 80 mm. for 6 cm. sq.) The lens has no shutter and its aperture setting ring has positive 'click' stops which can be set by feel. The apertures are usually marked in exposure ratios—1 : 2 : 4 : 8 etc.—instead of f numbers. A different focal length should be used for each negative size—if the focal length is too long it is impossible to make usefully big enlargements, and conversely a lens with an excessively short focal length will not sharply image the negative corners.

2. Most enlargers have simple lenses (known as condensers) between lamp and negative carrier, to give even illumination to the negative. When changing the enlarger lens or greatly varying the size of enlargements these condensers usually have to be changed, or the lamp moved up or down in its lamphouse until even lighting is restored. Check the makers instructions.

3. All other factors being equal, the taller the enlarger column the larger the maximum size enlargement it will produce. The height of the darkroom ceiling may be the limitation here. Some enlargers allow the head to be swivelled around to the back of the column to project from the bench direct onto the floor, whilst others pivot about a horizontal axis and project onto the wall (figure 32).

4. The enlarger head should not appreciably spill light, and no light at all should reach the baseboard except via the lens. The lamp must not heat the negative so that it will not lie flat. Whilst cover

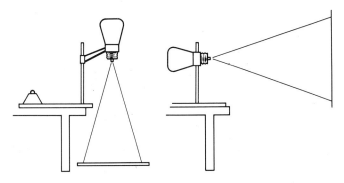

Arrangements of an
ger for increasing
row for big
gements.

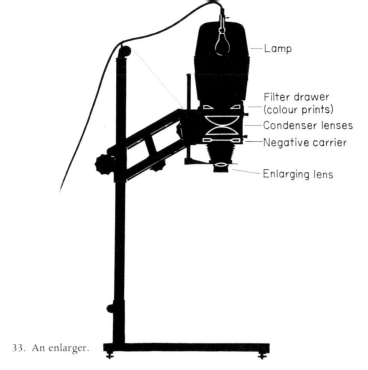

—Lamp

Filter drawer
—(colour prints)
—Condenser lenses
—Negative carrier

—Enlarging lens

33. An enlarger.

glasses in the negative carrier help to maintain its essential flatne
they constitute another four surfaces to be cleaned of dust each time
negative is changed.

5. Enlargers for 6 cm. wide negatives are often designed to allo
change of lens, condensers and carrier to accept 35 mm. negative
but few also accept 5″ × 4″ negatives. The jump in negative si
between roll-film and 5″ × 4″ sheet film is so great that a su
stantially larger machine is needed. The cost of enlargers is of cour
a factor to consider when deciding which size cameras to buy.

PRINTING Black & white printing papers vary in their size, thickness a
MATERIALS colour of base, the colour of the image they produce, surface textur
and contrast grade. The most common sheet sizes are show
opposite in table 6. Papers are marketed in 'single weight', which
about the thickness of office notepaper; 'double weight' similar
thick cartridge paper; and 'airmail' weight. The colour of the actu
paper base is limited to white, ivory, and cream, although one fir
makes printing paper with red, yellow, and green bases.

The light-sensitive emulsion coated on papers used for enlargi
contains silver bromide (hence the material is known as bromi

[1] Kentmere Ltd. (Kentint papers).

94

TABLE 6 Printing paper—popular stock sizes

Non Metric	Metric (standard continental sizes, not exactly equivalent to non-metric formats)
$4\frac{3}{4}$in. × $6\frac{1}{2}$in. ('half plate')	
$6\frac{1}{2}$in. × $8\frac{1}{2}$in. ('whole plate')	12·7cm. × 17·8cm.
8in. × 10in.	20·3cm. × 25·4cm.
10in. × 12in.	25·4cm. × 30·5cm.
12in. × 15in.	30·5cm. × 40·6cm.
16in. × 20in.	40·6cm. × 50·8cm.

(Metric sizes are gradually replacing the non-metric formats traditionally used in Britain and America)

paper). Chlorobromide papers (e.g. Kodak 'Bromesko') are also available and have silver chloride present to give an image 'colour' which is very slightly greener or browner than the more neutral black of a bromide paper image. Manufacturers also offer their printing papers calendered in a range of surface textures, ranging from dead matt through stipple and glossy to 'rayon' and even more exotic textures. Glossy surfaced paper has an extra top layer of gelatin. Allowed to dry naturally, prints on this paper have a smooth semi-matt surface, but if dried in contact with a polished surface (see glazing below) takes on a high gloss finish.

Each type of printing paper is made in a range of contrast grades. They are internationally coded as Grade 1 soft; Grade 2 normal; Grade 3 hard; Grade 4 very hard. Contrasty negatives should be printed on a soft grade and flat low contrast negatives on a hard grade. Some glossy papers (the ones most commonly used) are also made in grades 0 and 5. Less popular combinations of paper colour and surface texture are only available in grades 2 and 3.

When deciding which printing paper to use look through the sample books available at most photographic retailers. If you are printing for the first time buy some white glossy single weight bromide paper in grades 2 and 3. 10″ × 8″ is a useful size. This is also the type of material most often used to make photographic prints for final mechanical reproduction.

Other printing materials. Apart from paper, photographic printing materials are also produced with plastic, film, glass, or fabric bases. It is even possible to buy emulsion in cans to spray canvas and other surfaces.

Lith paper (e.g. Kodak Kodalith LP) is extremely high contr
and, processed in lith developer as used for negatives, gives a li
image direct from a continuous tone negative (plate 53). Prints
this paper have very rich blacks. Alternatively, various degrees
under development give a range of yellow/chocolate colour
images. Lith paper is thinner than bromide paper and it also h
to be handled under *red* instead of orange safelights. Lith prir
can be made on paper with a *translucent* base (Kodalith TP) which
sufficiently transparent for printing down onto silk screens.

Printing materials on transparent film bases include normal ar
high contrast $5'' \times 4''$ sheet film (e.g. Ilford N5.31 and N5.50) ar
normal contrast 35 mm. bulk film (e.g. Kodak 'Positive' film). The
films handle exactly like bromide paper and can be processed
print developers. They enable us to make black & white positi
transparencies for projection, and positives which can themselv
be printed to give negative images on paper, or manipulated imag
(see 'solarization' page 100).

MAKING PRINTS *Contact printing.* As described earlier, the easiest way to conta
print under the enlarger is to project an even patch of light onto
sandwich comprising sheet glass, negative (emulsion downward
and printing paper (emulsion upwards). By using a sheet of $10'' \times$
paper, four $5'' \times 4''$ negatives or twenty-five 35 mm. negatives
strips of five can be printed at one time. The emulsion side of tl
negative is the *dull* side; the emulsion side of glossy paper has a slig
glisten under the safelighting. Make sure that the glass is really clea
and heavy enough to hold the sandwich flat.

Exposure meters are seldom used for black & white printing. It
usual to make a test exposure, on a strip of paper. Start off with Grac
2 paper, using the lens stopped down two stops, and give an exposu:
time of 10 seconds.

Slide the exposed paper quickly under the developer and keep
rocking gently for the full 2 minutes. This is the most interestir
stage of printing because the bright orange safelighting allows u
actually to watch the image appearing. Always give full develoj
ment even if the print seems to be coming up too dark—lightness c
darkness must be corrected by exposure, *not development*. After
few seconds in the water rinse, plunge the test print into the fix
for about 1 minute and switch on white light to assess results.

If the print looks too light, more exposure is needed and vic
versa. If the light print just shows subject shadows as pale grey, tr
giving twice the exposure time. If this makes the time uncomfor
ably long (say over 30 seconds) keep to the original time but open u

the lens one stop—this has the same exposure effect.

Conversely a dark print in which only highlights are distinguishable from black may need $\frac{1}{2}$ to $\frac{1}{4}$ the exposure time or the lens closed down 1 to 2 stops. If after these corrections the next print is approximately correct for density but too contrasty or too flat, change to grade 1 or grade 3 respectively. When negatives differing in density are contact printed together on one sheet, it may be necessary to make two or more prints—one correctly exposed for the denser negatives and one for the thinner negatives.

The main value of sheets of contacts is that they show the whole of every photograph exposed. We can now save a lot of work by deciding which negatives are not worth enlarging. Choices can be made between pictures, cropping marked up in grease pencil, and local areas which will need shading noted. Contact sheets are also useful in filing: bags containing the negatives can be stapled to the back of their sheet.

Enlarging. Using the correct lens and condensers for the size of negative, position the negative in the carrier, emulsion side downwards, and sharply project its image on the baseboard at the print-size required. This is made easier by using a sheet of white paper the same size as the final print, or an adjustable masking frame. Obviously at this stage we can decide to exclude unwanted parts of the image on the negative, making a square picture into a rectangle and so on. Ensure that illumination of the negative is even—if necessary briefly remove the negative carrier and check the appearance of the light patch on the baseboard. The lamp may need repositioning. Stop the lens down until the image is judged to require an exposure in the region of 10–12 seconds. This is largely a matter of experience, but even with a very dense negative try to close the lens down to at least one stop below full aperture to increase its depth of field, in case the negative is not absolutely flat.

To make an exposure test, place a strip of paper across a part of the image that is typical of the whole. (Many enlargers have a safelight filter which can be swung under the lens—this enables the paper to be suitably positioned without actually exposing). It may be possible to give two or three different exposure times along the strip and thus get more information from the test. Once processed assess the test in terms of density and grade, and then make a complete print at the most suitable exposure time.

The full print may show unevenness—either because of uneven lighting of the subject, or subject brightness-range almost beyond the range of the negative. Shading may then be needed. Use the

 masking frame;
inged upper part of
etal frame covers
dges of the paper
g exposure, giving
white border.

hands close under the enlarger lens to cast soft edged shadows ov
those parts of the picture which printed too dark. Keep the han
slightly on the move throughout the period of shading, so that edg
of the shaded area do not record as too sudden changes of densit
Decide the required shading time and keep checking the clock
that the entire operation is always under control.

Sometimes a small piece of black card on a stiff wire is helpful
shade dark shadow 'islands' surrounded by tones which do not ne
shading. Conversely a hole in a card can be used to give addition
exposure to isolated areas which otherwise print too light. (Plate 2

When a satisfactory print has been made it must have at least
minutes fixing. Keep the print face down in the fixer and move
occasionally so that fresh chemicals can act on the emulsion. T
print is next washed in running water for 20–30 minutes, and c
then be pegged on a line or left face up on absorbent paper to d
naturally. Alternatively glossy paper can be squeegeed wet into co
tact with a polished sheet of chromium-plated metal which forn
part of an electrically heated glazing machine. As the print dries t
paper surface takes on the glossy finish of the metal. A glaze can
removed at any time by resoaking the print and then letting it d
naturally.

Small white or black spots on prints (usually due to dust or dir
working) can be hand retouched on the dry print surface. Use bla
watercolour on an 0 size brush to fill white spots with a close patte
of grey dots. The area should appear as a continuous tone matchi
its surrounding seen from normal viewing distances. Black mar
can be obliterated in the same way using diluted process whi
poster colour, or gently brushing the surface with a very sha
surgical blade or broken razor blade until the black is reduced dov
to a suitably matching grey tone.

35. Sequence of contact
printing and enlarging
using (a) bromide paper
for dish processing, and
(b) special stabilized
bromide paper for
machine processing.
Both papers must be
handled under orange
safelighting only. Clock
faces show accumulative
time.

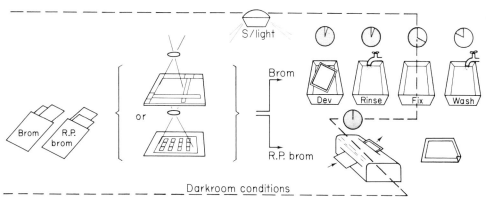

Machine processing of prints. As an alternative to print processing using dishes of solution, it is now possible to use a small processing machine. The machine contains motorized rollers which apply an alkali 'activator' followed by a 'stabilizer' to the paper emulsion surface. Special bromide paper is needed. The picture will bleach or discolour in about 3 months unless refixed and washed in the normal way. However, the machine allows printing to be greatly speeded up, is very adequate for proofing, layout work, or for images for reproduction, and does away with the need for a wet bench and plumbing in the printing room. Such machines cost £80 to £150.

Print quality. 'Quality' in a black & white print is today highly subjective in that so much depends upon the original aims of the photographer. Generally, however, a good quality print should have really rich blacks in its darkest shadows, and clean highlights closely matching white paper. Between these extremes there is then room for a wide range of well-separated grey tones.

A processing line for paper.

Blacks will not be rich if the print received insufficient development, or was under-exposed on a paper grade too soft in contrast. White will be greyed or stained if the print was greatly over-developed, processed in exhausted developer, or if the enlarging lens was dirty, stray fogging light reached the paper, or the paper was very old. See plate 36.

Photographs for reproduction must have a good range of separable tones; as the blockmaking process itself inevitably reduces tone range. Make the prints on glazed glossy paper—this makes the blacks even richer when the print is suitably lit. Never use stipple surfaced paper as its tiny highlights cause technical difficulties with the blockmaker's screen.

Printing on a hard paper results in well separated but a very restricted number of tones between black and white, culminating in (lith paper) black and white only. This gives stark graphic quality which in itself reproduces well, as the blockmaker can treat it as a line image. All the silhouettes of photographic equipment in this book were produced this way, using extremely soft subject lighting reflected off a white canopy, and printing the negatives on lith paper.

Soft prints have an extremely wide range of barely separable greys which can be helpful for romantic high or low key images—but on the whole it is better to achieve these effects by the original lighting and camera work, allowing printing to emphasize rather than make the total effect.

Line negatives consisting of dense black and clear film would

seem very easy to print because no greys are required. In practi take care not to over-expose as this slightly 'spreads' black letterin, making it appear unsharp. A good line negative prints well on ar grade because all grades give good blacks and whites—only th range of greys varies.

Special Techniques. There are several ways of manipulating th image during actual printing—corrugating the paper on the ease moving it in jerks or spinning it during part of the exposure, or prin ing from two negatives. The two negatives can be sandwiche tightly together in the negative carrier of the enlarger, in whic case the detail of one negative will print through the clear areas the other. For example, one negative may show a sewing machir shot in silhouette against a white background whilst the other h. an over-all image of massed flowers. Combined together the flowe will only print in the silhouette area, which of course is clear on th first negative.

Alternatively the two images can be exposed separately onto th one sheet of paper—either by changing negatives in the carri between exposures or using two enlargers. If the sewing machir and flowers negatives are used this way the flowers will only prin over the *background* area (the paper here was unaffected by the fir exposure). The sewing machine itself will print black. These effec are interesting variations on the traditional cut-and-paste methoc of montage and collage. Plate 2 is another example.

Drawn or painted images on film or very thin paper can be en larged or contact printed to give negative images. Actual objec can be placed on the printing paper surface to cast shadows—wir or without a negative in the enlarger. Softer outlines are created objects are suspended on glass shelves several inches above th paper, and if the object is removed after part of the exposure, gre instead of white silhouettes are formed. These shadow images direct cast by actual objects are called 'photograms'. See plate 8.

If printing paper exposed to a negative image is briefly fogged white light about half way through its development time and the developed to completion, a strange partial reversal of tones tak place. Lines of lighter density also form along the boundari of light and dark areas. This effect is known as 'solarization'. F more controllable results print the original negative onto 5" × blue sensitive film such as Ilford N5.50, solarizing this and the contact printing it back conventionally onto another sheet of th same film. The resulting negative can then be printed normally give solarized prints. Images suitable for solarization should l

sharp, fairly contrasty, and free from spots and blemishes.

After-treatments. Prints can be chemically intensified or reduced over-all, but this is usually more trouble than simply making a reprint. Farmers reducer solution is a useful means of slightly lightening odd dark areas of large prints. This will, however, often produce stains if we try reducing too much density. Iodine bleacher (4 gm. of iodine plus 15 gm. of potassium iodide in 1,000 ccs of water) is probably the most useful of print chemical after-treatments. It is the only bleacher which will safely reduce an area down to clean white paper, e.g. making skies of backgrounds plain white, and enabling elements in a photograph to be completely isolated. The solution is applied by brush or cotton wool and the strong brown stain removed in fixer. The print is then washed.

The black image on a print can be toned various colours, the most familiar being sepia. We start out with a fully processed and washed bromide print which is then bleached and redeveloped in sepia toner. The necessary chemicals are sold in small quantity packs. If desired local areas only of the image can be bleached and colour toned.

When mounting photographic prints use photographic mountant, rubber gum, or (preferably) dry mounting. Some adhesives which are satisfactory for mounting drawn artwork contain chemicals which in time would bleach or stain a photographic image.

TABLE 7 Images obtainable from a black & white negative

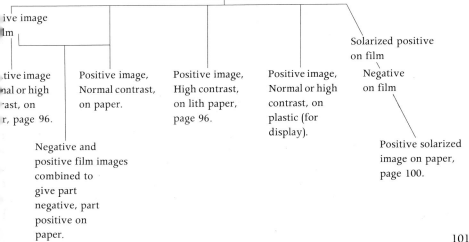

Colour Photography

Taking photographs in colour is not really much more difficult th
shooting in black & white. More technical care has to be taken b
cause the film is much more expensive than black & white stock, an
there are rather fewer opportunities to correct or manipulate resu
after shooting. On the other hand we no longer have the frustratio
of communicating multicoloured subjects in terms of grey tone
Much of the handling of photographic equipment also appli
equally to black & white and colour work, and has already been d
cussed. This chapter will try to concentrate on *differences* betwee
the two forms of photography, both in techniques and visu
approach.

COLOUR FILMS
Modern colour films are able to record the colours of an image b
cause, basically, each carries three emulsion layers. One layer re
ponds to blue light only (rather like bromide paper), another lay
records the green parts of the spectrum only, and the third lay
records red parts only. So we can really think of colour film as thr
kinds of black & white film, inseparably coated one on top of t
other.

During rather complicated processing different chemical dy
are formed in these three layers, so that when finally the process
film is held up to the light the dyes—either singly or in combinatio
—reproduce the colours of the original image. Of course *accur*
reproduction of all the many colours we may image on colour film
asking a great deal of a few chemically formed dyes. Neverthele
the general acceptability of much colour photography we see aroun
us proves what a high standard chemists and dye technologists a
able to achieve.

How do films differ?
When buying a colour film we have to consider film size; wheth
colour transparencies or paper prints are required; the type of ligh
ing which will be used when shooting; processing by user
laboratory; and the film speed.

Size. Colour films are made in the same popular sizes—roll, she
and miniature films—as black & white materials. 35 mm. cassett
are available containing 20 and 36 exposure lengths; also quick lo
cartridges. Sheet film is packed in boxes containing 10 sheets. It
not possible to buy colour plates.

Plate 37

A portrait taken in the National Portrait Gallery of the Director Roy Strong.

Plate 38

A multi image effect created by using a multi faceted prism attachment over the camera lens.

Plate 39

Rabbit and conjuror – a studio shot using electronic flash. Here shape and the expression very much emphasize the character of the man.

Plate 40

A family group lit by daylight in the studio and shot on high speed film to give a profusion of grain, and add to the Victorian effect.

Plate 41

Stanley Spencer, taken in the window of his bedroom at Cookham. Some daylight was reflected back into the shadows on the left using a sheet taken from his bed.

Plate 42

Augustus John. Taken in weak daylight in the artist's studio on high speed film. When taking portraits one must be incredibly quick to catch transient expressions.

Plates 43 and 44

Vaughan Williams (*left*) and Stravinsky (*right*) taken on high speed film in existing light. An essential requirement in shooting photographs such as these is that camera, focussing and aperture are pre-set to allow the photographer to concentrate on expressions and situations as they arise.

Plates 45 and 46

Portraits taken under weak lighting conditions at 1/15th of a second at f1.5. The blur (part subject movement, part camera shake) resulting from the slow shutter speed, plus shallow depth of field, give greater emphasis to the pictures.

Plates 47 and 48

Two portraits of Peter Cook showing how one can exploit every possibility of facial expression.

Plates 49 and 50

A single portrait of Lord Fisher of Lambeth from which two prints have been made. Each was then divided down the middle, the left side put with the left side and right with right giving (apparently) two completely different people.

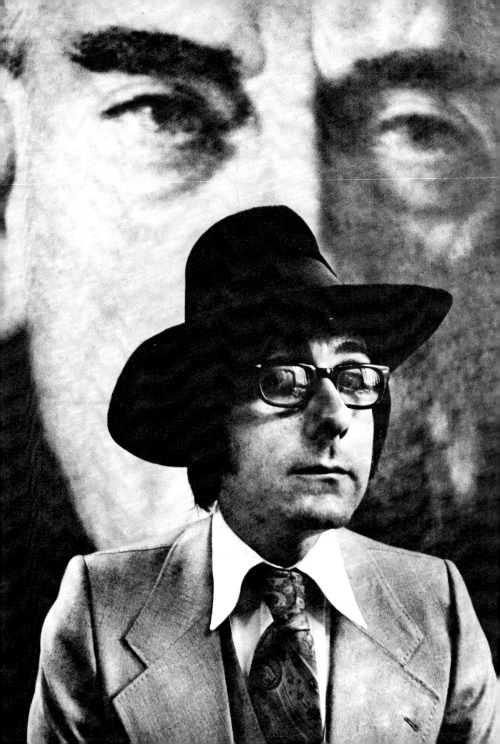

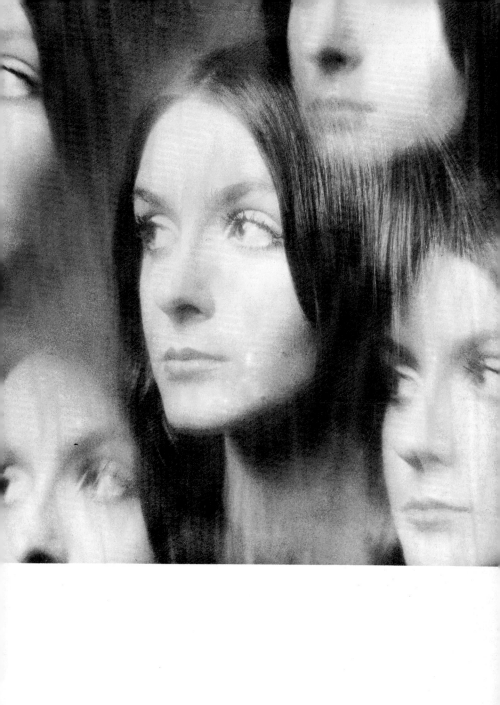

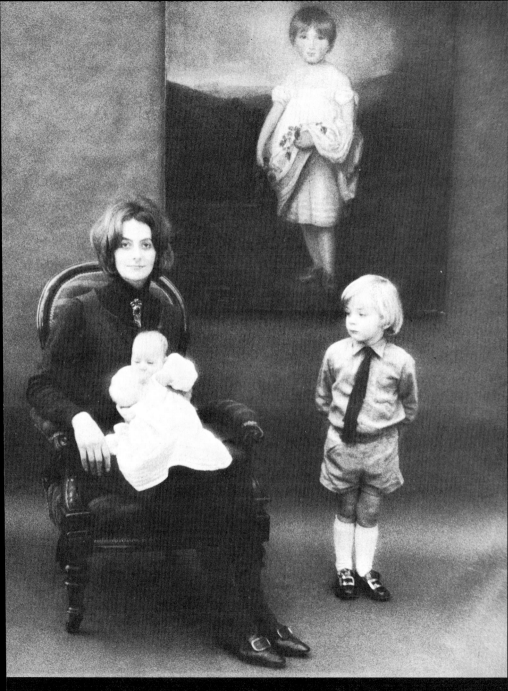

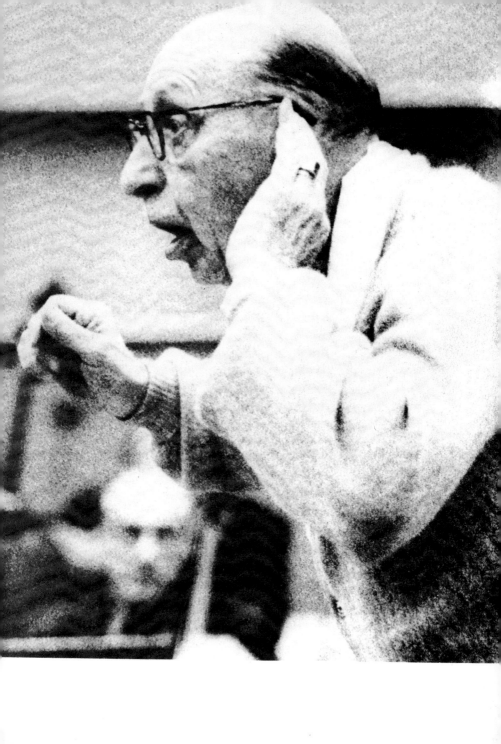

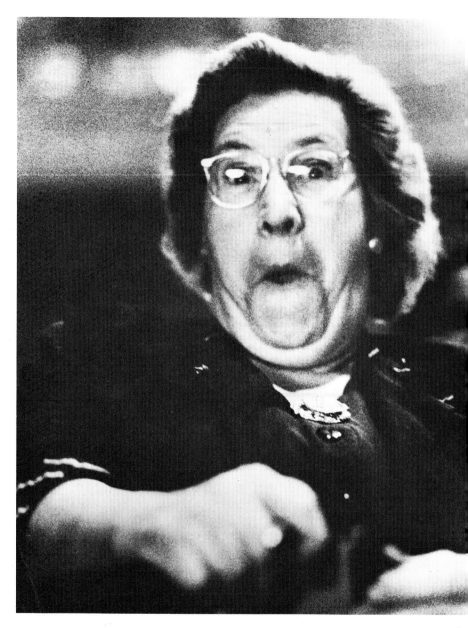

45

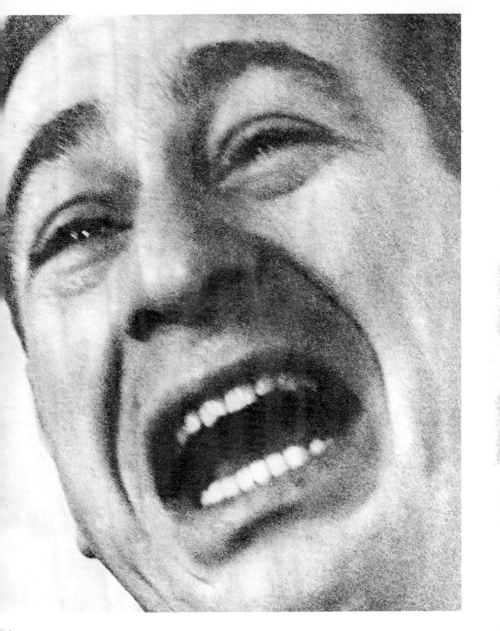

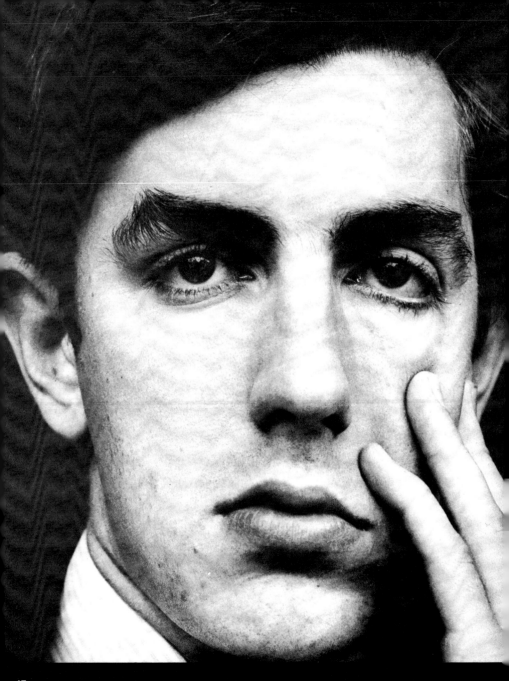

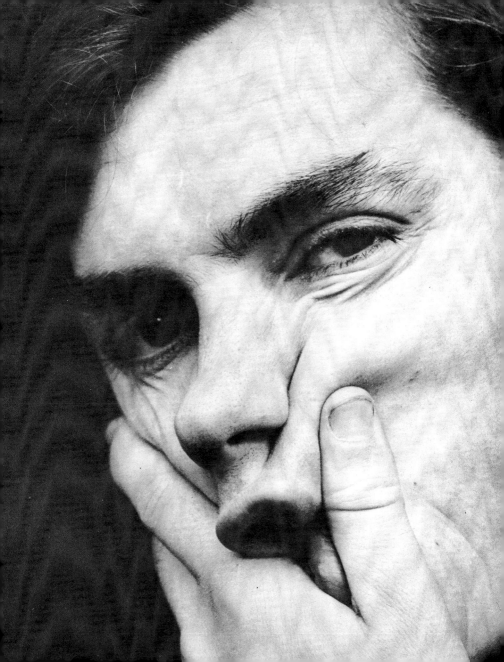

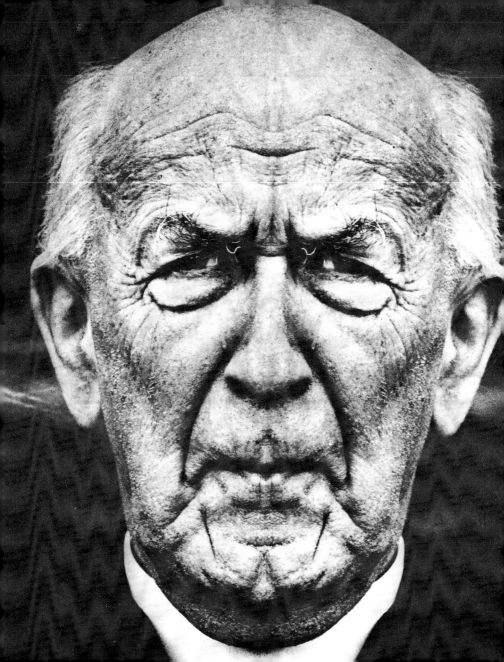

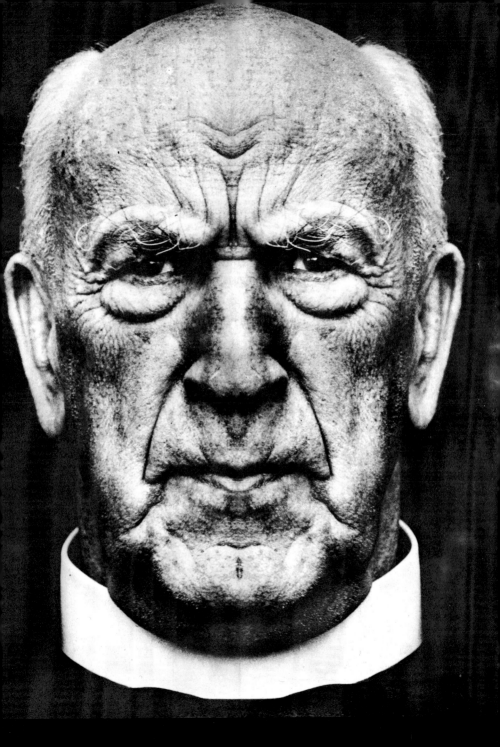

Reversal or Colour Negative? A 'reversal' colour film (e.g. Koc chrome, Agfachrome or Ektachrome) is intended to be processed that the actual film exposed in the camera is returned bearing positi colour transparencies. These may be already cut up and mounted cardboard frames, ready for projection. Since negatives are not i volved and there is no printing stage, reversal film (in small form; at least) offers the cheapest means of producing colour photograpl Against this, the production of results in one stage means that l manipulation is possible, and visual and technical accuracy at t camera stage become all-important.

Colour prints can be made from reversal colour transparenci direct onto reversal colour paper. Alternatively a colour negati can be made from the transparency and colour prints made frc this. One can also make a black & white negative by contact printii or enlarging the transparency onto panchromatic film. Black white prints can then be made from this negative in the usual way

A colour negative film such as Kodacolour or Agfacolour carri after processing, an image in which colours are complementary a tones negative relative to the original subject. Yellow parts of t subject record blue, whites black, and greens magenta. In additi many makes of colour negative film have an apparently over- orange stain. This strange appearance makes the negatives rath difficult to assess.

Colour negatives can be contact printed or enlarged up dire onto colour print paper (or print film) to give positive images, explained later in this chapter. They can also be enlarged direct on bromide paper to give black & white prints, although the tone r production of colours is rather distorted this way and strictly *pa chromatic* printing paper should be used instead. The main reasc for shooting on colour negative film when colour prints are final required is that colour accuracy is more likely to be maintained. Tl manufacturers arrange that the negative film has contrast ar colour dyes specially matched to the printing paper rather tha aiming to produce an intermediate which itself looks good (as in tl case of a transparency used for printing). Also it is possible to c more manipulation in shading tones, altering certain colours, ar other effects when printing colour negatives.

Colour balance of lighting. Remembering that a colour film has thr carefully adjusted emulsion layers, the manufacturers have to kno something about the *colour* of the lighting under which photograpl are to be taken. Tungsten lamps, for example, produce illuminatic which is richer in red than sunlight. If a colour film is to give accura

118

images (particularly neutral tones) free of faulty colour casts it will have to be made with its emulsions 'balanced' for *either* tungsten *or* daylight lighting, but cannot work well with both. Thus we meet a feature not found with black & white films—different film types are made for use with different light sources.

In order to keep the variety of film colour balances on the market down to a reasonable minimum, manufacturers offer reversal films in three different forms:

1. 'Daylight' film, balanced for use when the subject is illuminated by daylight (strictly a mixture of sunlight and skylight, or hazy sun). Electronic flash and blue tinted flashbulbs also give light of this colour. *Examples: Agfacolor CT; Kodachrome Daylight type.*

2. Artificial light or 'type B' film, balanced for studio lighting such as 500–1000 watt spotlights and floods. *Examples: Agfachrome CT: Ektachrome type B.*

3. 'Photoflood' lighting or 'type A' film, balanced for the bright, short-life tungsten lamps obtainable cheaply at most photographic shops and popular among amateurs. Only a few films, such as *Kodachrome type A,* are made for this lighting.

In each case the type of lighting for which the film is intended is clearly marked on the box.

A film balanced for daylight gives results with a strong orange cast when used to make pictures with studio lamps; conversely, type B film shows a strong blue cast when used in daylight. (Plates C 12 & 15.) Other light sources, such as low-wattage domestic lamps and clear flashbulbs, have no film of exactly matching colour balance. The best remedy is to select film of the nearest balance and then use a pale correcting filter on the camera lens—the manufacturer's packing slip gives details.

Similarly a strong orange filter can be used on the lens when the camera is loaded with type B film and *has* to be used in daylight (e.g. when changing from indoors to outdoors halfway through a cassette of film). In general, however, try to use the right film for the particular light source. Above all don't use mixed light sources on the subject unless special effects are wanted.

Colour *negative* films are not as critically colour balanced as reversal types, because some correction of cast is possible by filtering at the printing stage. However, printing is made somewhat easier if the photographer illuminates his subject in the first place with sources recommended by the film manufacturer—for most brands it will be daylight (or electronic or blue flashbulbs). See table 8. Again, avoid using mixed light sources.

TABLE 8 A sample range of films for colour photography (1970)

Speed	Brand Name	Colour Balance	Notes
Films giving colour transparencies			
25	Kodachrome II	Daylight	35 mm. only. Able to resolve finest detail. Processing by manufacturer. (N kits available)
40	Kodachrome II Type A	'Photoflood' lamps	
50	Ferrania CR 50	Daylight	
64	Ektachrome X	Daylight	
32	Ektachrome Type B	Photographic lamps	Sheet film only
50	Agfachrome CT 18	Daylight	
125	High Speed Ektachrome Type B	Photographic lamps	
160	High Speed Ektachrome	Daylight	
500	Anscochrome 500	Daylight	Some sacrifice of colour quality fo speed
Films giving colour negatives for printing			
80	Kodacolor X	Preferably daylight	Roll film only
80	Agfacolor CNS	Preferably daylight	Not sheet film
100	Ektacolor S	Preferably daylight	Roll and sheet fil
100	Ektacolor L	Preferably photo-graphic lamps	Sheet film only

Processing type. All colour negative films and most reversal tra parency films are intended to be processed by the user, or commercial colour laboratories accepting film direct or via chem and photographic shops. Sometimes these colour laboratories run by the manufacturers themselves or their agents, and address appears on a slip packed with the film.

After a May Ball at
nbridge, photographed at
0 a.m. A smoke bomb was
d to help to strengthen the
st which was thin that
rning. Various exposures
re made, using a
nbination of filters from
low to green to give slight
erations in colour. Taken
h a normal focal length lens.

Wedding group' picture
en on a fashion session for a
gazine. Again smoke was
d to separate the foreground
m the background. Taken
h a zoom lens, using the
m movement during the
er part of the exposure time
h of a second). Several shots
re taken, as this technique is
gely trial and error.

Taken for a magazine cover.
absolutely straight
otograph of a girl partly
merged in a shallow pond.
e lighting was diffuse
light.

Girl in bath. One of a series
relationships photographed
the studio for a German
blication. Two electronic
sh heads reflected off white
brellas provided the
mination.

Hands beauty shot for a
sy magazine. This is a
bination of three separate
ographs. The two models
: taken on infra red
chrome film in the studio,
g an extreme wide angle

The (third) window
transparency was taken on
location but remained
undeveloped. Each of the two
transparencies were then
projected in turn through the
enlarger direct onto the
exposed window film.

6 Jewellery illustration. The
model was first photographed in
monochrome and a 24″ × 30″
bromide print made. The
jewellery was then arranged on
top of the print and the whole
set photographed on colour
film in the studio.

7 A brochure illustration for
Perrier, taken in the studio.
The café window design was
painted on a plain sheet of glass
and placed in between the still
life and the camera. Control of
depth of field is important here
to give the right separation
between the decoration on the
glass and the still life on the
table. The set was lit with one
floodlight, slightly behind and
to one side of the table.

8 A tea advertisement, one of a
series of conversation pieces.
Close viewpoint and a wide
angle lens give a steep
perspective to the table. The
neutral background and table
covering were chosen to
simplify the image and thus
emphasize the products.
Lighting was by diffused flash
from one side.

9 A studio shot on 5″ × 4″
Type B Ektachrome. Care was
taken to choose good specimens

of the fish and to shoot them
quickly before the fish scales
lost their gloss. The plate and
textured background were
chosen to give emphasis to the
simplicity of the fish shape and
colour.

10 An illustration for a cookery
page in a weekend
supplement. This picture
started off absolutely crowded
with fruit, fowl, and fish, etc.
By gradually eliminating
various items the strongest
image came about by the
minimum of content. The set
was lit with four 500 W lamps
reflected off a white ceiling.
Photographed with a wide
angle lens on a 5″ × 4″ camera.

11 A journalistic shot taken
with existing daylight, using
35 mm. single lens reflex.
Photographing children, whilst
very rewarding, demands the
fastest shutter speeds because of
the quickness of their
movements. This often means
limited depth of field but
usually expression is more vital
than critical overall sharpness.

12 Nude, taken for an LP
record sleeve. Soft unusual
lighting was requested. This
effect was achieved by using
artificial light colour film with
daylight illumination, plus a
soft focus lens and pale red
filter. Note how the filter
coloured the highlight areas
whilst being too weak to have
much effect on the shadows.

13 Hairstyle. Shot against a distant (studio) background which was underlit to give emphasis to the hair. Top lighting by electronic flash.

14 Advertisement for a furniture firm shot on Ektachrome using a 5 × 4 in. camera, and wide angle lens 1/60 sec. at f.11. This eviction scene was staged with the help of specially chosen models and props. The mist, already present, was intensified with smoke. Much depends upon the organizing ability of the photographer with this type of picture. The idea was to break away from the conventional 'hard sell' type of advertisement, and by making people look at the photograph draw their attention to the name of the product rather than individual items shown. Often such pictures have to be done experimentally; in this case the client disliked the association of ideas and the picture was not finally used.

15 One of a series taken on witchcraft, for a foreign magazine. Shot in existing daylight, using artificial light film. The camera was mounted on a firm tripod and after the exposure time of 1 second the film was quickly wound on with the shutter still open, so giving the 'streaky' effect.

16 Record shot of part of a stained-glass window in Ely Cathedral. To obtain the best colour results in photographing stained glass windows unwanted areas of window should be masked off with black paper or cloth. Where possible have even lighting from behind, and choose a camera viewpoint to avoid distortion.

17 A wall painting of a religious subject in a temple in Ceylon – taken for a book illustration. The great difficulty in photographing paintings is the fact that highlights reflect back light to the camera. This is particularly true of frescos and mosaics, which are often painted or laid on uneven surfaces. Care should be taken that the camera is parallel to the painting to be photographed, and the illumination is even and suitable for the colour film.

18 An editorial illustration for drinks. Taken in existing daylight with a long focus (250 mm.) lens on a $2\frac{1}{4}''$ sq. camera, using a fast shutter speed and wide aperture. The shallow depth of field combined with the distant viewpoint and long-focus lens increases the effect of being half submerged in the grass and flowers of the meadow.

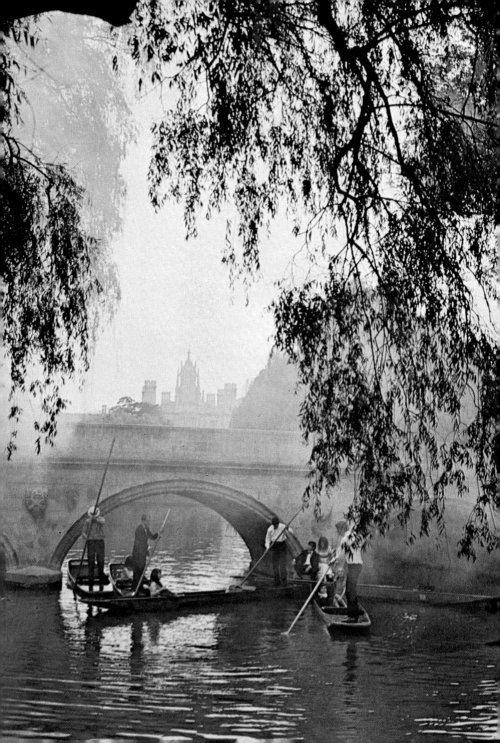

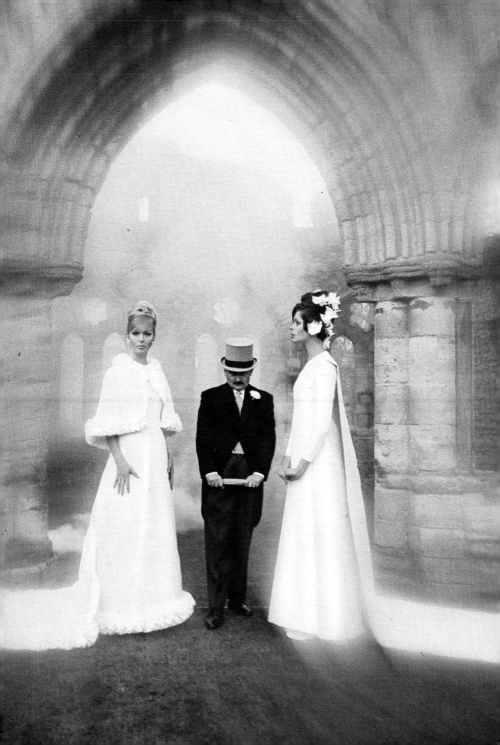

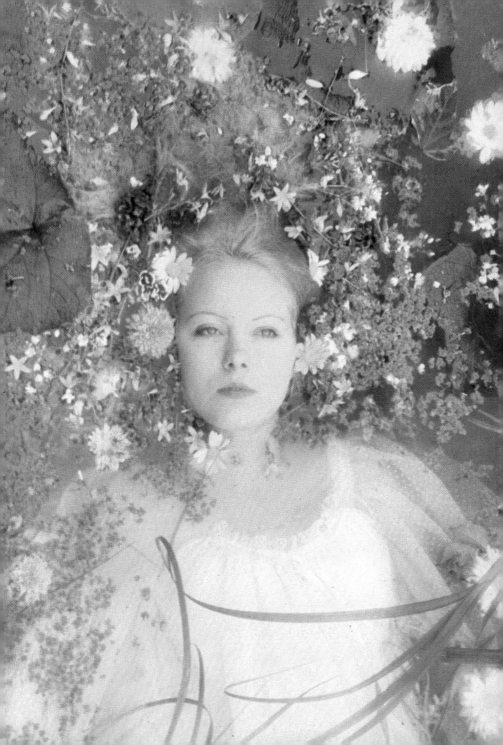

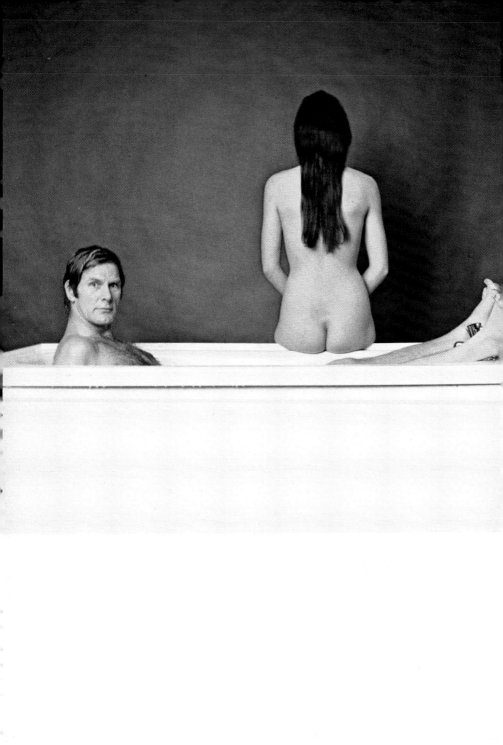

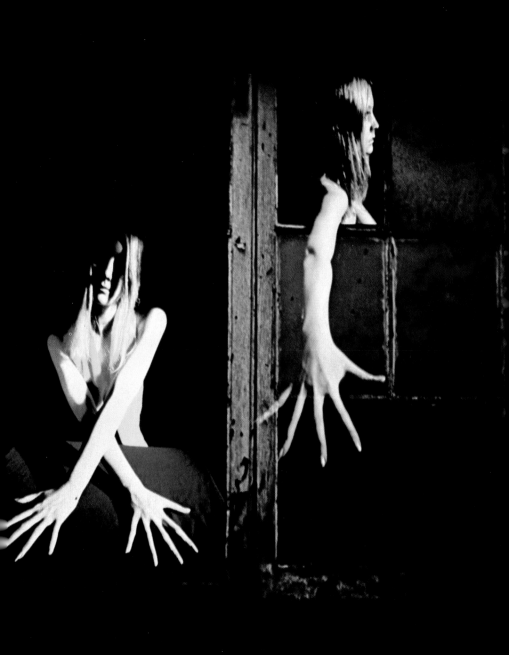

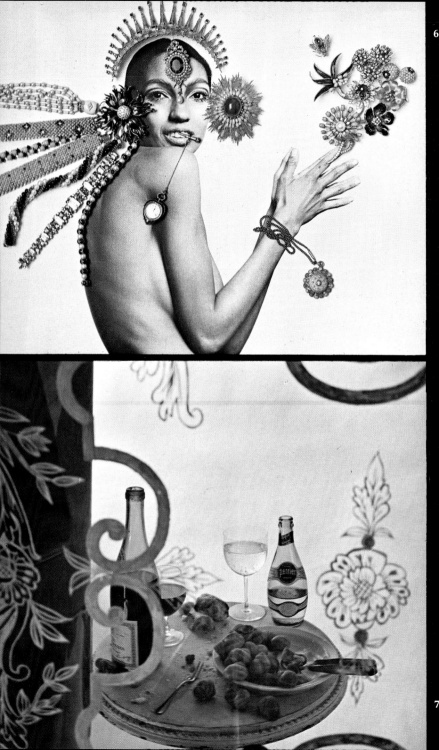

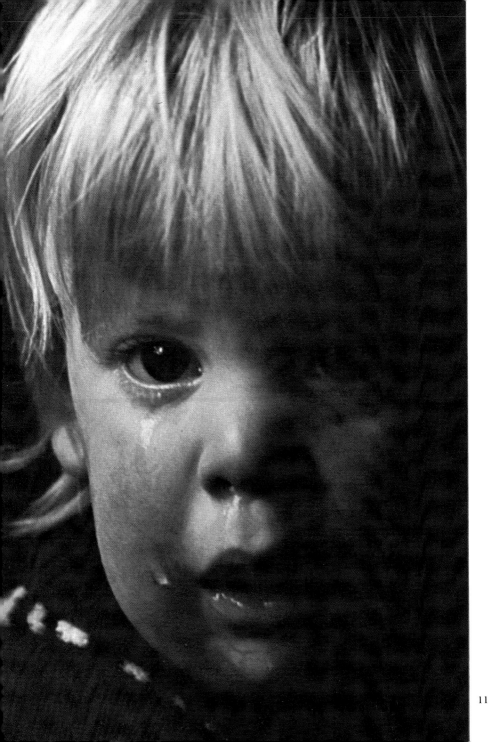

12

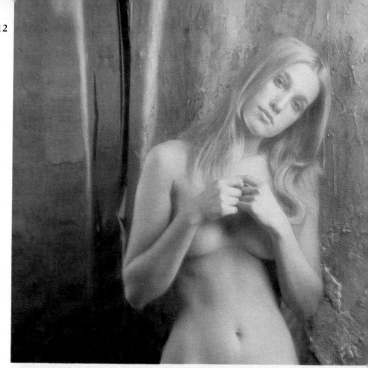

13

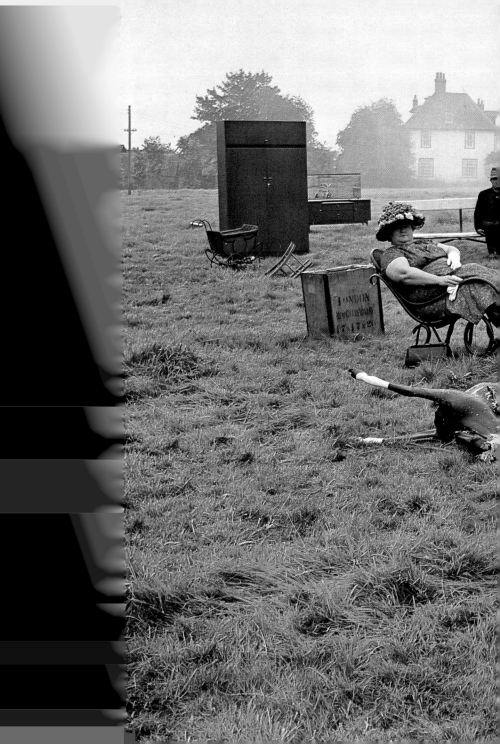

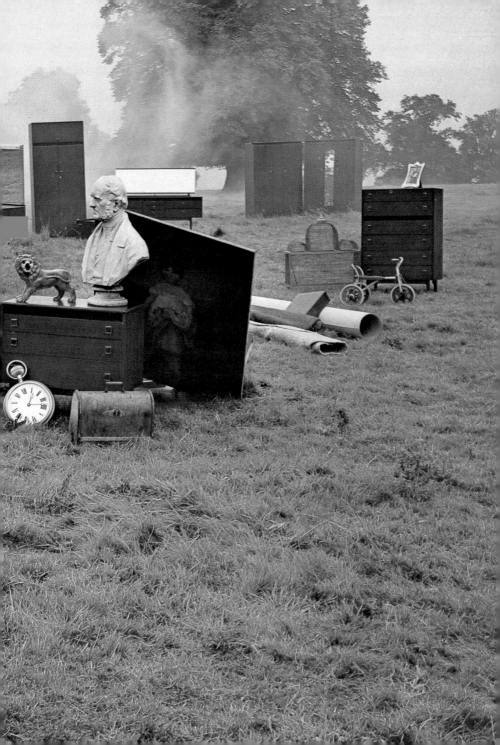

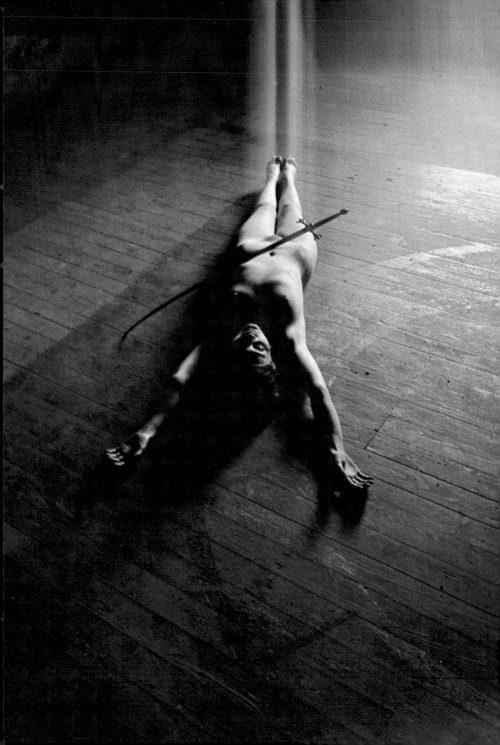

▷
16

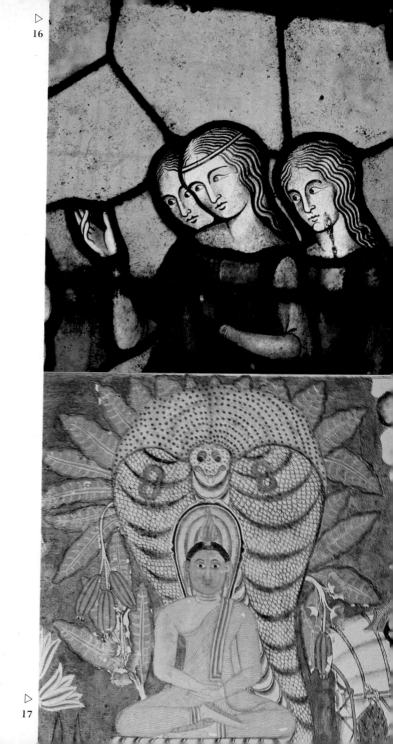

▷
17

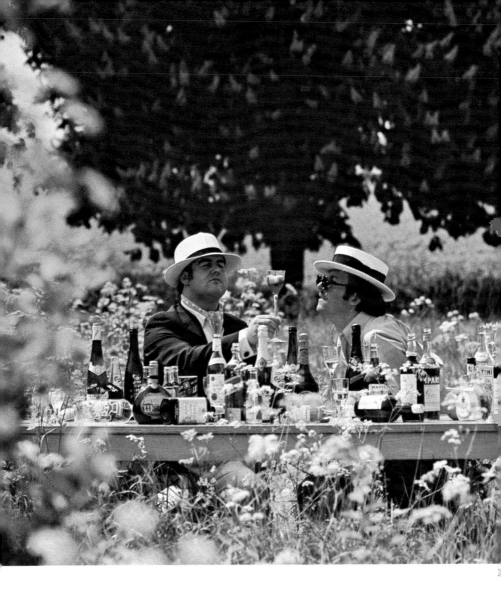

A few reversal films—notably Kodachrome—are based on early forms of colour chemistry requiring extremely complex processing, in most countries carried out only by the manufacturers themselves. Such films are usually sold inclusive of processing charges, and the packet contains a little bag for sending it to the processing station. Centralized processing of this kind means high standards but may delay results for a week or more, particularly during the holiday season.

Film speed. A comparison of tables 2 and 8 shows that colour films are inherently slower than black & white films. Very high speed colour film (ASA 500 and above) tends to give some loss of image quality—in particular a degrading of colour in subject shadows. As with black & white materials the faster colour films tend to give lower contrast, and there is also a tendency for a slight mealy grain-like pattern to appear. These fast colour films are valuable for news and journalistic work under poor conditions, or on odd occasions when a slight degrading is required for its own sake, e.g. to help the mood of a photograph.

Much professional photography is shot on film of more moderate speed (even down to the ASA 25 of Kodachrome II when the subject allows, owing to the latter's outstanding ability to resolve fine detail). Most user or laboratory processed films can be exposed at ASA ratings twice or three times the figure quoted on the box, and then given additional processing in compensation. Results have less colour accuracy and shadow detail than normally exposed film, but this procedure can be useful in an emergency. High Speed Ekta-chrome rollfilm is an excellent material for 'pushing'. Of course the laboratory must be specially notified when the film is sent in for processing.

Cost. Colour photography is expensive, particularly if large colour images on paper or film are required. Size for size colour film costs about three times as much as black & white stock. To this about another 80% must be added to cover the processing cost. Colour prints from colour negatives cost about ten times the cost of black & white printing, in paper and chemicals alone.

Many laboratories offer a service of lower cost colour prints (usually from negatives, but sometimes also from transparencies). These may be made by semi-automatic machine to a fixed size, e.g. 'Colourstats'. Cheap colour prints of straightforward subjects are quite satisfactory for less critical work, but where highest standards of accuracy are required—copies of paintings for example—printing

by hand is essential. This always costs more because of the time a̶
skill involved.

Beware of offers of cut-price colour films. All film boxes carry ̶
expiry date, and if this date has passed changes in speed and colo̶
rendering can be expected. Much depends on storage conditio̶
and the only way to assess a batch of outdated film is to expose so̶
to a familiar subject under fixed lighting conditions and check t̶
processed results.

Which film to choose? First of all decide what sort of final result̶
required. If projectable colour transparencies are needed use rever̶
film (35 mm. film with inclusive processing charges works ȯ
cheapest per exposure). If results are wanted quickly use a us̶
laboratory processed film—most commercial laboratories w̶
process in 2–3 hours if the work is delivered and collected. If t̶
colour picture is required for reproduction in a magazine or boo̶
colour transparencies are quite satisfactory unless artwork is to̶
added to the image.

Perhaps the final result must be a paper print—in which case b̶
a colour negative film. Remember that shooting on negative fi̶
allows a little more margin for error in exposure and colour of lig̶
ing. The negatives only can be processed, and then printed on
black & white paper before deciding which ones are worth colȯ
printing.

Having decided between reversal and negative stock, rememb̶
to choose the film type balanced as closely as possible to the lig̶
source to be used. If the *amount* of lighting will be poor, choose a f̶
film and if necessary up-rate its marked speed. Finally we are l̶
with a choice between brands, Kodak, Agfa, Ansco, etc. Most
these manufacturers make a range of colour films broadly comp̶
able in speed and performance, but each firm has its own patent
chemical dyes. This difference in the dyes used creates subtle diff̶
ences in the appearance of colour images. Much of this is unnotic̶
if one keeps to one manufacturer, but if the same subject is shot ̶
several different brands of film and the results examined side-b̶
side, differences (the recording of greens and reds, contrast, etc.) ̶
very apparent. All are acceptable, and choice often depends up̶
personal preference. Try to avoid mixing several makes of film i̶
set of colour slides or prints.

Little has been said about grain and contrast. General purp̶
colour films do not vary as much in these respects as black & wh̶
stock, and all tend to be fairly fine-grained. Where a grain patter̶
required, shoot on a fast colour negative film, keeping the im̶

small and giving considerable enlargement when making the print. In general contrast decreases with speed, and there is some advantage in choosing slow film for copying artwork. For line work a special high contrast colour film 'Scienticolor' is available, described below.

Special colour films. Agfa Aviphot film. A very high contrast 35 mm. colour negative film intended for copying maps and other line originals. The film is slow in speed and requires extreme accuracy in exposure.

Infrared Ektachrome. This is a false colour rendering reversal colour transparency film devised originally for camouflage detection. One of the layers in this film is sensitive to infra red, and the film records all living green vegetation as red, lips, flesh and most red objects yellow, yet maintains blue skies as blue. Further emphasized by its high contrast, these startling and bizarre distortions have made the film useful for certain fashion work (plate 5) and dream-like sequences in films. This is a very interesting material to try, once one has first mastered conventional colour photography.

Polacolor. Like black & white polaroid film (page 41) the physical arrangement of this unique film allows a finished print to be peeled from the camera within a minute or so of shooting. (No re-usable colour negative is produced.) The quality of the colour print produced this way is acceptable—especially for portraits—but not particularly accurate. Polacolor prints have a characteristic warmth of colouring which makes them immediately recognizable. Cost per exposure is the highest of all colour film.

SHOOTING IN COLOUR

No special camera is required for colour photography—after all, the lens of every camera will form an image in colour. But, as with black & white photography, the better the lens, the wider the range of shutter speeds, and the more accurate the method of focusing the greater are the opportunities for technically good results.

Start off with a roll of reversal colour film (e.g. High Speed Ektachrome), daylight type. Set out to produce twenty interesting transparencies with a wide range of subjects and lighting conditions. Don't be inhibited by having expensive colour film in the camera, but at the same time remember that there are differences in visual approach between black & white and colour photography. Instead of relying on textures and tone contrasts, delicate nuances of colour can now be used to strengthen mood, heighten tension and contribute to form. Resist the obvious temptation to shoot brightly coloured subjects—colour should add significance rather than simply bring greater realism.

Use the exposure meter in the same way as for black & white work. If possible take readings of darkest and lightest important areas and choose the exposure for midway between the two. There is less room for exposure error with colour film so try to make a reading for every shot.

When shooting one of the subjects—preferably a scene with wide range of brightnesses—make two further exposures, one with the lens opened up a stop, and one with the lens at a stop smaller than the f number judged for correct exposure. Try at least one frame of subjects lit by fluorescent tubes, and one with a household lamp, or mixtures of these and daylight. Include some blur photographs of moving subjects, and try shots of cars and busy lighted streets after dark (try 4 seconds at f16, in some cases moving the camera around during the exposure).

This film will have to be processed by a local colour laboratory—ask them to return it in one long strip. The quickest way to assess transparencies is to hold them in front of a window or a light box (colour matching tubes) faced with opal plastic. Try always to assess your results against the same illumination source.

You will probably find the results rather better than you expected. Note from the three frames shot at different f numbers that the less exposure given (higher f number) the *darker* is the result. This is the opposite to negative making. Unintentional over-exposure has the effect of losing highlight detail and generally washing out density and colour. If in doubt about exposure when shooting reversal colour film tend to give *less* rather than more—if the results are for reproduction the blockmaker can always make more of a slightly dense transparency than a weak one.

Note too how just one stop difference in exposure has had a much greater effect on results than would have been apparent on black & white film. If the subject was quite contrasty the under-exposed frame probably shows much better reproduction of highlight detail than the 'correct' frame. Similarly the over-exposed frame may have better shadow detail. The film has more difficulty in recording light and dark areas together in the same picture than black & white stock. Conversely, frames exposed in hazy sunlight where only faint shadows were present show excellent contrast and detail; the film is also fully colour balanced for these lighting conditions.

Other points to remember when shooting the next film are:

1. Colours are desaturated by over and by under exposure. Therefore assertive, unwanted colours can be suppressed by local over or under lighting relative to the main subject.

2. Subjects photographed totally in shadow on a day with sun

shine and clear blue sky show a strong blue cast. This is because they receive only light from the sky. Similarly the portrait of someone standing near a large well lit coloured surface or even the green leaves of a tree shows a strong colour cast.

3. Daylight film records subjects under tungsten lamps with a strong orange cast, and under striplights with an unearthly greenish bias. If weather conditions are heavily overcast, absence of sunlight will give transparencies a bluish cast.

Try the next test film on a subject or subjects in the studio. Use type B High Speed Ektachrome, and light the set with 500 watt floods and spots. Be gentle with the lighting—make use of large white reflectors to illuminate shadow areas. Don't allow light reflected from nearby coloured surfaces (e.g. walls) to reach the set. If working close-up remember the calculation for increasing exposure (page 166). Slight errors may pass unnoticed with the more tolerant black & white film but can spoil results in colour.

After this next film has been processed and assessed, mount up the most interesting transparencies so far, and project them on a screen in a well darkened room. A good projector should reveal a great deal more image detail and 'depth', particularly in shadow areas.

When shooting on colour negative material for the first time assess the strange looking results by noticing how much subject *shadow detail* the film has recorded. Unlike reversal transparencies, underexposure of colour negative film is a more serious defect than overexposure. Composition, expressions, and general tone gradations can be checked by contact printing the negatives onto (grade one) bromide paper, but colour reproduction subtleties cannot be judged at this stage without using special instruments. Select the most promising negatives and ask the laboratory to make colour contact prints or enprints.

Remember that, owing to the degree of control possible at the printing stage, the colour printer may make a completely inaccurate print if the subject is totally unfamiliar to him. When prints are ordered of abstract images, copies of artwork, textile designs, paintings, etc., try to show him the original subject, or supply a reasonably accurate colour transparency of it as a guide.

One advantage of using colour prints for blockmaking is that they more closely approximate the final reproduction on paper. Retouching of blemishes, local colour changes, lettering and other artwork can be carried out on the print surface. Against this a colour print is never quite as sharp as a first-class, original, reversal transparency.

Filters in colour photography. Camera filters serve a more restricte role in colour photography. The ones most likely to be used are U-V absorbing filter, and various conversion and batch correctic filters.

Landscapes and distant scenes, particularly at high altitudes near water, contain a high proportion of scattered ultra-violet ligh Although this is invisible to the eye it records on colour film to give blue cast and over-exposure of distant detail. A U-V absorbir filter effectively cancels out this difference between what is see and what is recorded. The filter itself appears to be colourless gel tine; it has no effect on level of exposure and can be left over the le at all times if desired, helping to protect the lens from dust.

The most useful conversion filter is Kodak's Wratten 85B—orange filter made for use whenever type B colour film has to exposed in daylight instead of studio tungsten lighting. Two-thir of a stop extra exposure must be given.

TABLE 9 Images obtainable from a colour negative or reversal transparency

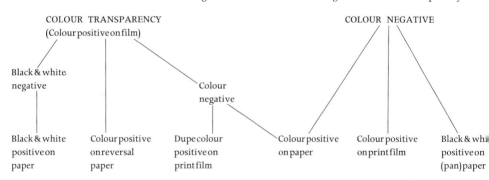

Correction filters are very pale in colour, and intended to counte act slight batch-to-batch variations in colour film. These filte come into their own when attempting strictly objective recording paintings etc. Each box of sheet film contains a note stating wh; corrections are advisable for optimum results, particularly whe exposure times are to be rather long. Kodak supply gelatine filters i various strengths, CC 05, 10, 20, etc., in either yellow, magent. cyan, red, green, or blue. Usually any required correction tends be towards pale yellow or green. 05 and 10 filters in these colou should be ample.

PROCESSING AND
PRINTING COLOUR

Most photographers process and print their own monochrom materials, as individual attention at these stages helps to strengthe and carry through the original intention of the picture. Colour, how

144

ever, is much more demanding in terms of temperature, time, agitation, and solution control, calls for more expensive chemicals and several extra items of hardware. There is also less opportunity to manipulate post exposure results. Commercial colour laboratories exist which not only do a fast service but give consistent results. When only occasionally processing colour the cost per film processed rises sharply and consistency is very difficult to achieve. The decision whether to attempt user processing and printing or send it all out therefore depends upon volume. Unless 10–15 35 mm. films or equivalent are processed per month (the life of a typical set of chemicals) it will be cheaper to use a laboratory.

Film processing. The actual physical manipulation of colour film during processing is similar to that of any other film. Spirals, film clips, and tanks are used in the same way, except that more solutions are needed. Kits of powdered chemicals for all the necessary solutions are sold by makers of films which can be processed by the user; e.g. Ektachrome, Agfacolor, Ferraniacolor, and Ektacolor. Quite separate kits are required for each type of film—there is no *choice* of developers, as in the case of black & white materials.

Solution temperature is very important and in the case of first developers should be accurate within plus or minus $\frac{1}{4}°$C. Similarly the periods of film agitation must strictly follow maker's recommendations. When using small roll-film tanks it is a good idea to have a tank body for each chemical stage of processing, plus one with a running water supply for rinses. The row of tank bodies can then stand in a flat bottomed sink or dishes filled several inches deep with water at exactly the required temperature.

The first stage (colour development) of colour negative processing is the most critical. This forms negative black silver and dye images simultaneously in each layer. The function of the remaining stages is to bleach, fix, and wash away all the silver, leaving a dye image only.

Processing of reversal transparencies takes a little longer because extra stages are needed to give a positive image. The critical first development forms a black & white negative in each layer. This black silver is then bleached, and the parts of the emulsion not developed or bleached are exposed to light. Exposing a film evenly to light in the middle of processing sounds awkward. Fortunately most spirals are made of clear plastic, so that by holding the film still in its spiral and rotating it a foot or so from a bright lamp, even fogging occurs. All subsequent processing stages can take place in white room lighting.

The fogged film next goes into another critical solution, the colour developer. Here the fogged remaining silver halides develop as positive black silver and dye image in each layer. As in negative processing the remaining stages bleach and remove the silver leaving a dye image—this time a positive.

Colour Printing. A good enlarger used for black & white printing can also be used for colour—provided it has a tungsten light source, a good quality enlarging lens, and a means of colour filtering the image. Filters are very important in colour printing as they enable us to control the over-all colour balance of a print, while the degree of printing exposure controls its lightness or darkness.

There are two alternative ways of colour filtering: (1) Using filter drawer rather like a negative carrier but located in the lamp house just below the lamp. We then buy a set of sheet gelatine colour printing filters for the make of colour paper we intend to use (e.g. a set of 22 Kodak filters). These filters are various densities of yellow, magenta, and cyan, individually quite pale but able to be used in combinations giving thousands of permutations.

(2) Using only three filters (strong blue, green, and red) one at a time on the enlarging lens. Every print is made by giving short exposures through each of the three filters, so that by varying the relative exposure times a wide range of filtration effects can be achieved.

The filter drawer method is the more expensive of the two printing systems, owing to the cost of necessary filters. Use of tricolour filters is cheaper, but the need to give three exposures each time makes printing slow.

The printing paper itself is coated with three emulsions, similar to a colour negative. It is made in the same general sizes and packagings as black & white paper. Each box is date stamped and carries printing filter recommendations for the particular batch. As the paper is obviously sensitive to all visible colours it is handled in total darkness. An exposure timer linked to the enlarger switch and which can be set in the dark becomes essential.

The main skill in colour printing is to know what filters to use, as well as the most suitable exposure, shading, etc. The colour negative is set up in the enlarger in the same way as for black & white printing. Filters are chosen (or tricolour exposure ratios chosen) according to the enlarger, the paper batch, and experience of the negative being printed. Total exposure time must also be established, e.g. by making a test strip.

Once processed, the test is viewed and improvements made in

filtration and total exposure time before testing again and finally printing. Each manufacturer publishes a booklet (Appendix IV) on the practical handling of its colour materials; also helpful calculators and comparative prints to use in judging test strips. Sometimes a more effective print of a particular subject may be possible by 'cross printing' one maker's colour negative on another's colour paper, but generally this just over-complicates colour printing.

The processing of colour prints and test strips is similar to colour negative processing, although different solutions are used. Once again quite separate kits are made for each brand of paper. The paper can be processed in dishes but this method is particularly prone to give contamination of one solution with another unless extreme care is taken (remember the first three stages are carried out totally in the dark). Better still, the paper can be loaded into hangers or stainless steel mesh baskets and then processed in 16 litre tanks.

Small drum machines are also available which apply a small quantity of solution automatically to the paper emulsion surface. Such machines work so evenly that higher temperatures can be used than when dish or tank processing, and processing is completed in about 10 minutes instead of an average 20 minutes. Special kits of chemicals are used when machine processing.

Making a colour print tends to take far longer than black & white work, particularly if the printer needs to make several tests. Again the need for absolute consistency in processing cannot be over-emphasized. Things become completely out of hand if a series of prints, or tests and prints, differs in colour and density entirely owing to variations in processing.

It is possible to print colour negatives onto print *film*—colour print emulsion coated on thick film in various sizes up to rolls 30″ wide. Print film is handled under the enlarger in a similar manner to paper and receives the same type of processing. This material allows large display colour transparencies to be made which might otherwise call for a very large size of camera and reversal film.

Another useful colour printing material is *reversal* colour paper, which allows colour prints to be made direct from camera-exposed colour transparencies. The paper is of low contrast to compensate for the high contrast of most transparencies. Its processing involves rather more stages than normal colour paper and is not unlike reversal colour film processing. Similar low-contrast reversal 35 mm. film is made for direct duplication of reversal transparencies. Originals are either contact printed or printed same-size through the enlarger.

Special techniques in colour printing. Apart from filtering the colour balance and controlling the density of the whole image as already described, several other manipulations are possible. The image can be locally lightened or darkened by shading or printing in through a hole in a card. Similarly a really skilled printer may be able to change a local area of colour by shading it during part of the main printing exposure and then printing in this area again through a colour filter.

Colour transparencies printed direct onto conventional colour paper give a colour negative image (colours complementary and tones reversed, relative to the original subject). Black & white negatives can be printed on colour paper and filtered to give a range of single coloured images, or can be locally filtered to give areas of different colours. (Often, however, it is much cheaper and more controllable to locally colour tone a black & white print, page 101.)

Colour prints can be solarized by fogging to white or coloured light part way through development, or this technique can be used on a colour negative or positive intermediate on film. The result is then printed conventionally.

Interesting images are possible if the subject is still enough to allow two identical shots to be taken—one (slightly over-exposed) on reversal colour film, and one (slightly under-exposed) on colour negative film. The two somewhat thin images are then superimposed in register and colour printed as one. The resulting print is positive in highlight areas and negative in shadows. Colour prints can also be made from combined film images made up of colour and black & white negatives, colour and line black & white negatives or just 'hand made' negatives using dyes on acetate or pieces of coloured gelatine. Techniques such as superimposition and photogram described on pages 100–1 for manipulating black & white printing can be applied, with the added permutations of colour.

Subject problems in colour—copying paintings. This is a strictly technical job in which the photographer has to minimize the deficiencies and limitations of his materials. If the painting is finally to be mechanically reproduced on paper the blockmaker will usually prefer a good large format reversal colour transparency (e.g. $5'' \times 4''$ Ektachrome).

If slides are being made for projection, the photography can be direct onto 35 mm. (or 6×6 cm. roll-film) Ektachrome. If several slides have to be made from the subject make each of them original exposures—even if this takes time it is still cheaper and gives much better quality slides than having duplicate transparencies printed.

When the end product is to be a photographic colour print shoot on sheet film colour negative material such as 5″ × 4″ Agfacolor or Ektacolor L. If possible the colour printer should be given a sight of the original subject to know what to print for; this also applies to the blockmaker. Alternatively, a strip of card carrying white, black, and several shades of grey can be photographed alongside the painting and this later given to the printer.

All the basic technical requirements of black & white copying (pages 78–9) apply again for colour. The camera must be square-on, and the lighting even. Now, however, the actual colour of the lighting is most critical. Floodlamps must be of the correct voltage for the mains and reasonably new. Watch out for nearby coloured surfaces and the infiltration of mixed lighting. Use the meter to take shadow and highlight readings, or use its incident light attachment, if provided. Check whether the subject is sufficiently near to require extra exposure.

Batch recommendations packed with the film may advise using a colour correcting filter. The manufacturer also quotes the best exposure *duration* for maximum colour accuracy (e.g. for Ektachrome type B sheet film this is $\frac{1}{2}$ sec.). Adjust aperture and, if necessary, lighting until the meter reads this exposure time. If the light source is electronic flash remember to shoot on daylight type reversal film, or Ektacolor negative film, and try to diffuse or bounce the light. Direct light from flash can be very hard in character and paintings, which are intended to be viewed in diffused light, can be totally falsified if lit to give an over-exaggerated texture.

Daylight—preferably slightly hazy sunlight—provides an excellent light source, but avoid shooting near the beginning or end of the day when the light begins to turn orange. Direct sunlight can be used where textures must be shown but use a large matt white reflector to throw sunlight back into the shadows. A really black background for the painting becomes even more important when projection slides are being made—light toned surrounds become irritating distractions when projected.

Stained Glass. Most stained glass has to be recorded *in situ*—photographed from inside a building, using a sky background. At all costs avoid shooting against a blue sky. Bright diffused daylight conditions when the whole window is backed by even white cloud, are ideal. Direct sun over-emphasizes construction details such as ties and reinforcing bars, and creates too much contrast between dark and clear areas of glass. (Use mornings for shooting west and south facing windows, and afternoons for east windows.) (See plate C 16.)

Plate 51

A photograph of the moon taken on high speed film using 1/5th of a second at F1.4. Development was increased three-fold to give greater contrast and exaggerate separation of the rays of moonlight from the clouds.

Plate 52

See plate 36.

Plate 53

A line image produced by printing the original continuous tone negative onto high contrast lith paper. The print was built up from three negatives (fence, tree, and figures) printed in turn onto the same sheet of paper.

Plate 54

A fashion feature illustration for a magazine. The simplicity of the garment is contrasted b the multiplicity of the background.

Plate 55

Mont St. Michel. An advertising photograph taken for the French Government Tourist Office. This was photographed at dusk when light from the sky was strongl reflected in the water, giving emphasis to the silhouettes of the boat and the island. Exposure was calculated for se and sky rather than land areas

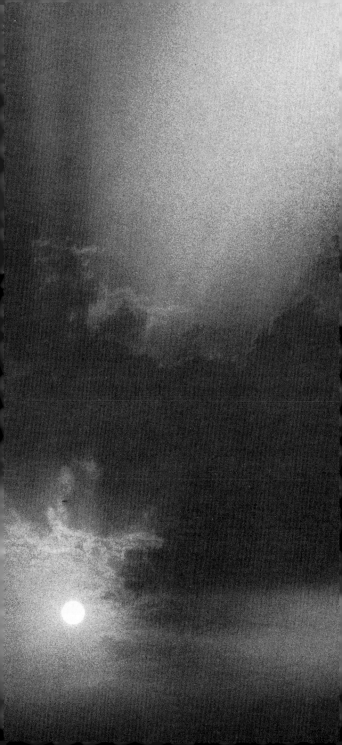

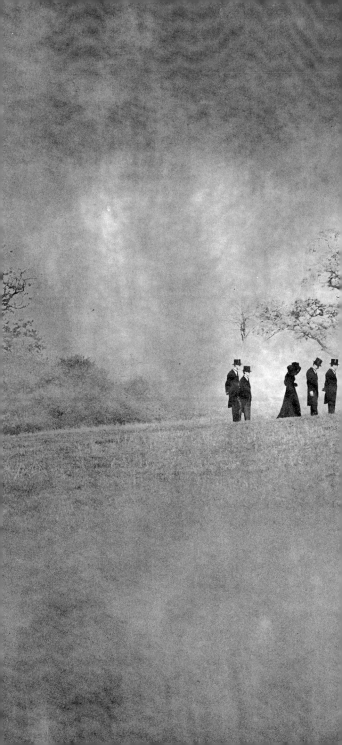

53

55 ▷ (overleaf)

Try to raise the camera to a position square-on to the centre of t[h]e window, to prevent converging vertical lines in the image. Loc[al] exposure readings of the glass are essential—be particularly caref[ul] not to over-expose on reversal material as this will seriously degra[de] the colouring. For obvious reasons colour transparencies are by f[ar] the most satisfactory way to present colour photographs of stain[ed] glass. If colour prints are essential be prepared for loss of saturati[on] and brilliance—and supply the colour printer with a colour tran[s]parency guide.

Three dimensional objects. Unlike flat originals where the range [of] tones and colours to be recorded is determined only by the wo[rk] itself, the surfaces of a three dimensional subject usually receive[s a] variety of light intensities as well. In the case of a ceramic bowl f[or] example, the range between light colours in the surface facing t[he] main light and dark colours located in shadow areas can great[ly] exceed the range between the two colours under flat lighting co[n]ditions. We therefore have to learn to compromise between the ur[ge] to use lighting to emphasize form and texture (so important in bla[ck] & white work) and the need to record accurately most of the colo[ur] and tone range.

Bearing in mind the contrast exaggerating characteristics [of] colour films tend to use softer lighting contrasts than appear sati[s]factory to the eye. Make plenty of use of white reflector boards a[nd] black shadow boards to control local areas. For example, arrangi[ng] that lighter areas of the subject appear against darker areas of bac[k]ground and vice versa helps to strengthen the appearance of for[m.] The image has boldness, but because subject highlight and shado[w] areas are only a few tones apart they still record with reasonab[le] colour accuracy.

Above all avoid switching on additional direct lights to redu[ce] shadows, only to introduce additional new ones. The more items [in] the picture and the more complex their appearance, the simpler c[an] be the form of lighting. Much can be done with one large, diffus[e] flood or flash grid to one side of the set, counterbalanced by a whi[te] reflector near the camera. See plate C7.

Professional Practice and Training

So far this book has been concerned with practical techniques for making photographs, and examples of the types of images offered by the medium. The aim of these final pages is to outline the ways in which contemporary photography is used, the organization and commissioning of professional photographers, and training for careers in this field.

Photography is so accepted today that it is difficult to conceive of newspapers, books, posters, and documentation of any kind without this form of illustration. Photography has an undeserved reputation for integrity—most people regard photographs as truthful when actually they can lie or distort as easily as words. The speed with which the camera can record moments in time in the finest detail is unparalleled. Reinforced by excellent methods of reproduction on the printed page, photography has never before been so universally applied.

As objective measuring tools cameras are packed into prototype aircraft to record vital instruments; they look into wind tunnels and cyclotrons to record the behaviour of specimens; they show us the detailed environment of the moon. Doctors can even put a lens (and light source) deep into a patient's stomach to make records in colour. Photography, as a visual notebook, records exactly what happens when one drop falls into a saucer of milk or when the fireball from a hydrogen bomb reaches its greatest dimension.

Industry uses photography to document research, to clarify specifications without language difficulties, to train its employees and sell its products. It is a cliché to say that a photograph is worth a thousand words, but photographs in newspapers can undoubtedly communicate with more immediacy than words. Through photography advertisers identify us with their products and services. Tin labels and cake boxes carry romantic pictorial visions of their contents. Books on travel, on the work of poets, architects, sculptors, and painters often rely heavily on sympathetic photography. At one extreme photographic prints are used as decorative murals; and at the other they are used to form functional electronic printed circuits too small to be seen with the unaided eye.

Such a wide diversity of applications requires equally varied abilities among photographers. As with writers working on tasks ranging from scientific theses to poetry, no one photographer has the know-how and temperament to handle every type of work.

Photographers therefore tend to work in particular—sometime quite specialized—fields, according to their interests and abilities.

Jobs and markets. Taking this country as a whole, professional photographers can be divided into three main categories: (1) men on the staff of internal photographic units of organizations (such as industry and medicine) unconnected with photography; (2) employees of commercially run photographic studios; and (3) free lances. Statistically most staff photographers work in industry several thousand companies in oil, electricity, engineering, and manufacturing industries of all kinds have internal photographic units, each staffed by up to half a dozen personnel, whose job is to handle all their company's needs of photography—accurate record of processes, the progress of jobs, general publicity, and illustration for house magazines.

Hospitals also make extensive use of staff photographers for medical illustration. Medical photographers document important operations, aid diagnosis and record the progress of treatments. In scientific research and development establishments, staff photographers handle report illustrations involving technical photography at ultra high shutter speeds, photomicrography (photograph through microscopes) and infra red and ultra violet techniques. As with medical photography, there must be specialist knowledge beyond the disciplines of photography itself, to understand the requirements of such illustrations.

Photographic studios are established in most towns of any size. Their work ranges from unambitious recording of weddings and portraits to commercial and industrial photography for local firms which are often too small to have their own staff photographers. These 'general practice' studios typically consist of the photographer a junior assistant, a printer, and a secretary/retoucher.

Sometimes a provincial town is the base for a photographer with more than a local reputation, but more often specialist freelance and the larger studios are located in major cities—notably London. Here are most of the publishing houses, the advertising agencies, headquarters of national organizations, model and picture agencies and processing laboratories. Such an environment encourage larger studios with twenty or more staff, often linked with graphic design and printing services.

Numerous freelances, assisted by perhaps one or two employees compete in the over-glamourized world of fashion and advertising photography. For the talented and successful few the financial rewards here are the highest in all professional photography, but

there are many more trying to make their way up, using shared or hired studios. Some freelances specialize in one extremely narrow field, e.g. ornithology, motor racing, yachts, insects. These have grown out of intense individual interests, to which they have been able to apply photography and in time build up markets and acquire a reputation.

Freelance photo-journalists make their living from magazines and newspapers, supplying feature pictures ranging from the animal/baby variety to substantial coverage of a major theme at home and abroad. Such photographers are essentially journalists; their work complements the many staff press photographers on local and national newspapers and news agencies covering 'hard' news.

Starting out on your own. The young photographer leaving art college or some junior position in a studio to set up on his own must be prepared to accept any commissions that come his way. He cannot afford to pick and choose but must hope to be able to drop the less 'stretching' uninteresting jobs in time, whilst developing the type of photography in which he has most to offer. It is very satisfying to be paid for the work you enjoy doing most.

To begin with there will be much seeking out of potential markets, showing work, taking trial photographs and shooting on spec. There is no protective organization as in a true profession, and a photographer is as good as his last job. Paper qualifications are of less value than a folio of outstanding photographs, so shoot as many good, interesting pictures as possible, building up files of negatives and transparencies. Use the medium to express your own point of view about things, and look at the best published photographs.

A nucleus of tried-and-proved photographic gear is essential, but many additional items—extra lighting, special lenses etc.—can be hired for particular jobs. Overheads are reduced by sharing a studio, secretary, and telephone, perhaps with another photographer or a designer. This sort of arrangement can be of mutual advantage but one should be beware of entering formal partnerships without long experience of working together, and clearly differentiating what each partner is to undertake.

Some guidance on fees and other aspects of studio management is available to members from the Institute of Incorporated Photographers. However, much still depends on individual business flair, ability to live on almost nothing in the early years, and tenacity in acquiring and satisfying clients. In short, life can be precarious during the early years of freelancing and many photographers

choose not to venture along this uncertain path until they hav
first had some years experience in responsible paid employmen

Commissioning photography. A designer buying photography i
buying technical reliability and creative ideas. Both aspects ar
always needed but it is the degree of visual imagination which mos
often distinguishes the man commanding the highest fee from hi
fellow photographers. Affinity between designer and photographe
is also important; and often the choice of a photographer is base
on this just as much as on specialized skills and experience.

When a required photographic illustration is essentially factua
such as a geographical location or the portrait of a well-know
person, money and time may occasionally be saved by using a
agency. Picture agencies hold large stocks of photographs taken b
freelances on their own staff. Each agency tends to specialize—on
may handle sport, another travel—as well as offering general sut
jects in both colour and black & white. Usually it is possible to buy
single reproduction right, or exclusive poster/book/periodic;
rights or complete copyright, according to fee and availability. Th
largest British picture agency is the Radio Times Hulton Pictur
Library; but many others are listed in the *Art Director's Handboo*
and in *The Writers and Artists Year Book*. One should also remembe
the large picture libraries held by industrial organizations such a
the oil companies. These sources are often free.

Usually it is much more satisfactory to have pictures speciall
taken for the job. If this involves shooting a subject located at th
other end of the country the decision has to be taken whether to pa
the expenses of sending a photographer, or use a local man on th
spot. Country-wide geographical lists of professional photographer
are published by organizations such as the Institute of Incorporate
Photographers. Similar registers are published by organization
abroad. Against the undoubted financial saving one naturall
cannot be certain of the standards of work delivered by an unknow
photographer, and briefings can be misinterpreted.

We come then to the most common requirement—studio an
local location work. According to the budget available and th
nature of the job, the designer might commission a photographe
with the highest reputation, or a competent if less imaginative ma
working at a lower fee. Obviously it would be foolhardy to emplo
a well-known photographer simply to copy some artwork or recor
a painting, when such work could be done well by most photogra
phers for a tenth of the fee. On the other hand the job may be a
interpretative illustration involving models, hired props, speciall

organized locations and equipment which in themselves cost thousands to set up. Here it would be equally shortsighted to save a few hundreds by hiring a less experienced and able photographer, and risk costly re-shoots because his approach was wrong.

The point at which creative decisions are left to the photographer varies with the man himself. Most leading photographers prefer to be given as much freedom as possible, having been drawn into the creative team to contribute suggestions at an early stage of planning. Such individuals are selected on the basis of their current work, sympathy towards the particular type of job in hand, and ability to work well with the team handling it. A photographer working at a lower fee may be happier with much more explicit visual instructions, layouts, etc., to be carried through without much deviation. He is less often consulted during the creative planning stages. The pattern described is by no means inflexible—a specialist photographer may be used purely because of the technical complexity of a job.

The copyright of a commissioned photograph is the property of the client, even though the photographer may retain the negative. He therefore becomes the sole source of reprints although these cannot be supplied to third parties without the client's permission.

Initial Training. Most photographers today train through college courses. Photography is such a mixture of art and science that young people really need a background of both, but owing to the division of secondary education in this country students enter higher education from one or other of these disciplines. The result is a division of motives for becoming photographers which perpetuates a split between technically and visually orientated photography.

Several other colleges in Britain offer three-year Diploma courses, and run shorter full-time or part-time vocational courses (Appendix V). Schools of Photography are located in Technical Colleges, and Colleges of Art and Design—backgrounds which influence the type of education given. Alternatively Dip.A.D. Graphic Designers are sometimes able to specialize in photography during their course. One college runs a B.A. Degree course in photography. (The Central London Polytechnic) and the Royal College of Art offers a post-Diploma M.A. Degree course.

The other way into professional photography is the traditional junior assistant progression upwards from teaboy/messenger in a studio, coupled perhaps with evening classes. This hard and in-efficient grind may be the only route for a young person without the GCE qualifications now considered essential for virtually every College course.

I. Suggested Further Reading

History

A CONCISE HISTORY OF PHOTOGRAPHY. H. & A. Gernsheim. London Thames & Hudson Ltd. 1965

ART AND PHOTOGRAPHY. Aaron Scharf. London: Penguin Books Ltd. 1968

Cameras

CAMERAS—THE FACTS. W. D. Emanuel and A. Matheson. London: Focal Press Ltd. 1963

Printing

ENLARGING. L. A. Mannheim and C. I. Jacobson. London: Focal Press Ltd. 1967.

DESIGN BY PHOTOGRAPHY. O. Croy. London: Focal Press Ltd. 1967

COLOUR PRINTING FROM COLOUR NEGATIVES. London: Kodak Ltd.

General (Introductory) Manuals

COMMONSENSE PHOTOGRAPHY. L. Gaunt. London: Focal Press Ltd. 1969.

BASIC PHOTOGRAPHY. M. J. Langford. London: Focal Press Ltd. 1970.

PHOTOGRAPHY FOR DESIGNERS. J. Sheppard. London: Focal Press Ltd. 1970.

LIBRARY OF PHOTOGRAPHY. (Eight titles). Time-Life Books. New York. 1971.

Technical Manuals

ADVANCED PHOTOGRAPHY. M. J. Langford. London: Focal Press Ltd. 1969.

MANUAL OF COLOUR PHOTOGRAPHY. E. S. Bomback. London: Fountain Press Ltd. 1964.

Applied Photography

THE GRAPHIC REPRODUCTION AND PHOTOGRAPHY OF WORKS OF ART J. N. C. Lewis and E. Smith. London: W. S. Cowell Ltd. 1969.

GRAPHIC DESIGN AND REPRODUCTION TECHNIQUES. P. Croy. London: Focal Press Ltd. 1968.

Professional Photography—Practitioners and Markets

I.I.P. REGISTER. Ware, Herts: Institute of Incorporated Photographers.

WRITERS AND ARTISTS YEAR BOOK.

Collections of Photographs

MOMENTS PRESERVED. I. Penn. London: Bodley Head 1961.

OBSERVATIONS. Avedon and Capote. London: Weidenfeld & Nicholson 1959.

PICTURE HISTORY OF PHOTOGRAPHY. Ed. P. Pollack. New York: H. N. Abrams 1963.

THE NEW LANDSCAPE IN ART AND SOCIETY. Gyorgy Kepes. London: Studio Vista 1956.

PHOTOGRAPHIS ANNUAL. London: Fountain Press Ltd.

Journals

CAMERA (Monthly) Zürich. Distributed by H. Greenwood & Co. Ltd., 24 Wellington St., London, W.C.1.

BRITISH JOURNAL OF PHOTOGRAPHY (Weekly). H. Greenwood & Co. Ltd., 24 Wellington St., London, W.C.1.

CREATIVE CAMERA (Monthly). Coo Press Ltd., 19 Doughty St., London, W.C.1.

II. Optical Calculations

1. THE POSITION
 AND SIZE OF
 IMAGES

F	U	V	M	E
Using a lens with a focal length of	A subject this distance from the lens	Is imaged this distance behind the lens	Relative to the subject image height is	Exposure indicated by meter must be multiplied by
5 cm.	150 cm.	5·3 cm.	$\frac{1}{29}$	$1\frac{1}{8}$* times
5 cm.	30 cm.	6 cm.	$\frac{1}{5}$	$1\frac{1}{2}$
5 cm.	15 cm.	7·5 cm.	$\frac{1}{2}$	$2\frac{1}{4}$
18 cm.	150 cm.	20·6 cm.	$\frac{1}{7}$	$1\frac{1}{3}$*
18 cm.	30 cm.	45 cm.	$1\frac{1}{2}$	$6\frac{1}{4}$

(* Insignificant)

Formulae: $V = (M+1)F$ $M = \dfrac{V}{U}$ $E = (M+1)^2$ or $\dfrac{V^2}{F^2}$

2. DEPTH OF FIELD

Diagram relates to a 55 mm. lens used on a 35 mm. camera. When sharply focused for a subject at distance *A* the lower pair of curves show how the zone of sharpness (depth of field) broadens as the lens is stopped down. When the camera is focused for more distant subject *B* the upper curves denote depth of field.

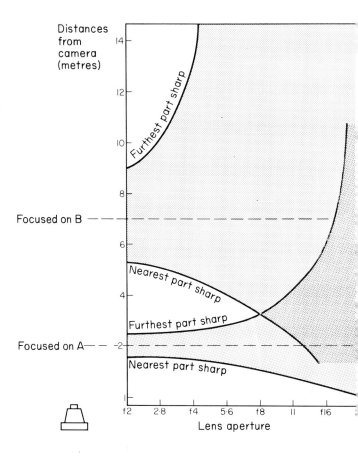

Distances from camera (metres)

Focused on B

Focused on A

Furthest part sharp

Nearest part sharp

Furthest part sharp

Nearest part sharp

Lens aperture

3. CAMERA MOVEMENTS

Most sheet film cameras allow 'camera movements' – independent swings and shifts of the front and back of the camera.
Left: Pointing the camera upwards to image a flat object gives a 'keystoning' distortion. Keeping the camera back parallel to the subject and only raising the lens images the subject with undistorted shape.
Right: Swinging the back of the camera when photographing an oblique surface greatly increases the depth of field across this surface.

166

| Appearance | | | Probable Cause |
B & W Negatives	B & W Prints	Reversal Colour Transparencies	
Thin, with shadow detail areas empty	Light, with highlight detail bleached	Dark, with shadow detail lost and often greenish	Under-exposure
Low contrast, but some shadow detail just discernible	Light and flat. Shadows lacking rich blacks		Under-development (too cold, too brief, or too weak)
Dense, with solid highlights and excessive shadow detail	Dark, with murky shadow detail and greyed highlights	Light, with highlight detail bleached	Over-exposure
High contrast. Highlights particularly dense	Veiled whites, slight over-all yellow stain		Over-development
Completely transparent (no edge numbers, 35 mm. & 120)	White paper		No development
Completely transparent but edge numbers show	White paper	Completely black	Unexposed
Completely black all over	Completely black	Completely transparent	Material fogged (e.g. to light)
Completely black in image area only. Edges clear	Completely black in image area. Borders white	Completely transparent in image area. Edges black	Fogged whilst in camera or slide or under masking frame
Image laterally reversed; slightly thin	Image laterally reversed; very light image	Image laterally reversed; orange cast; very dense	Exposed through *back* of material
Clearly defined white spots and squiggles	Clearly defined white spots and squiggles	Clearly defined black spots and squiggles	Dust and debris on surface of emulsion during exposure
Long black or white hairlines	Long black or white hairlines	White or coloured (e.g. cyan) hairlines	Abrasion marks due to careless handling
Light or dark marks showing fingerprint patterns	Light or dark marks showing fingerprint patterns	Light or dark marks showing fingerprint patterns	Handled with fingers contaminated with processing chemicals or water

The terms 'shadow' and 'highlight' refer to these parts of the *original subject*

IV. Suppliers of Materials, Equipment and Services

It is impractical to list here all the manufacturers and suppliers c photographic items. The following firms in London can be relied o to have a comprehensive range of the goods specified. Remembe too that today almost every item of photographic equipment can b hired, on a short or long term basis.

Cameras (sale and hire), meters, lighting, enlargers, processing tanks.
Pelling & Cross Ltd., 104 Baker Street, London, W.1.
Dixons Photographic Ltd., 27 Oxford Street, London, W.1.

Films, papers, filters
Agfa-Gevaert Ltd., 20 Piccadilly, London, W.1.
Ilford Ltd., 53 Berwick Street, London, W.1.
Kodak Ltd., Hemel Hempstead, Herts.
Kentmere Ltd., Staveley, Westmorland.

Custom built flash and camera repairs
Bowens Sales & Service Ltd., 72 Dean St., London, W.1.

Lamps and flashbulbs
Philips Electrical Ltd., Shaftesbury Avenue, London, W.C.2.

Background paper rolls
Wiggins Teape Ltd., Gateway House, Watling Street, London, E.C.4

Chemicals and equipment for processing
Johnsons of Hendon Ltd., Radlett Rd., St. Albans, Herts.

Colour processing, duplicating and printing services
Colour Processing Laboratories Ltd., Edenbridge, Kent.
Longacre Colour Laboratories Ltd., 161 Fleet St., London, E.C.4.

Special equipment—Endoscopes
Optec Reactors Ltd., 54 Upper Montagu St., London, W.1.

V. College Courses

At the time of writing the following British Colleges offer three-yea Diploma Courses in photography. Colleges marked with an asteris also offer Graphic Design courses (including Dip.A.D.) with a stron photographic element.

Birmingham Polytechnic*, Ealing Technical College and School o Art, West Surrey College of Art and Design, Guildford, Harrov Technical College, London College of Printing*, The Centra London Polytechnic, Manchester Polytechnic*.

The following College offers post diploma courses in Photography
Royal College of Art, London.

INDEX

Numbers in italics refer to plate numbers.
The prefix C denotes colour plate.)